For Sally

Hugs

David ∞ Cape Farewell

team

X David Buckland.

U–n–f–o–l–d

Edition Angewandte
Book Series of the University of Applied Arts Vienna
Edited by Gerald Bast, Rector

edition: ˈʌŋgewʌndtə

Edited by David Buckland and Chris Wainwright

U–n–f–o–l–d

A Cultural Response to Climate Change

SpringerWienNewYork

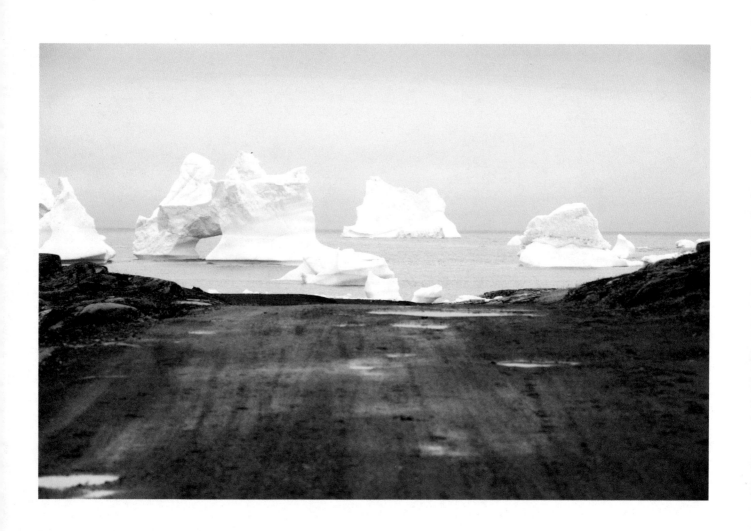

Contents

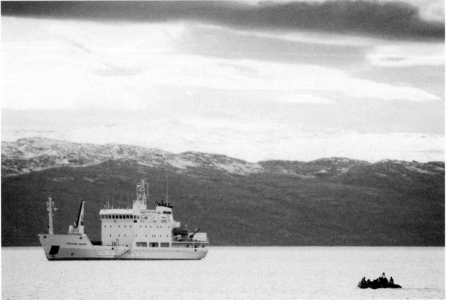

Editorial

Unfold brings together a body of work by a diverse group of artists, musicians and other creative practitioners, made in response to three Cape Farewell expeditions; the High Arctic 2007 and 2008 and the Andes expedition 2009. In addition to profiling the artists through both images and text, this publication contains contributions that broaden the discourse around climate issues from a number of invited writers, reinforcing the underlying ethos of Cape Farewell as an organisation, that along with its collaborative relationships, continues to promote the value and importance of a cultural response to climate change.

The title Unfold was chosen to reflect the emerging themes that developed out of the expeditions and how the intensive experiences of *seeing* the effects of climate change first hand were instrumental in creating a greater awareness in both scientific and socio-political terms. It also reflects the continuously *unfolding* debates and tensions that often exist in particular for artists, between raising awareness and creating influence, at the same time as preserving and maintaining a cultural practice that is grounded in a myriad of personal values, and emotions. This was, and remains, a central issue for many of the artists in Unfold as they attempt to post-rationalise this unique experience that carries with it both a sense of privilege and responsibility. It has always been the position of Cape Farewell to provide stimulus and challenge and not to set any expectations. Clearly this would compromise those artists whose practice, whilst being aligned to an ethos of environmental responsibility, quite rightly want to retain a necessary degree of autonomy. The work is often speculative, intuitive, and sometimes contradictory, and whilst it may have the expedition experience at its core, emerges in ways where it becomes submerged or modified through subsequent reflection. It is, however, interesting to see the extent to which there has been a shift in emphasis for some of the artists as a result of their involvement with climate issues and how it has influenced the course of their creative trajectory.

What was striking about curating and commissioning work for Unfold was how it developed through a genuine and productive process of collaboration between artists, musicians and scientists. The bringing together of these disparate groups of talented and highly motivated individuals, who on the expeditions had been confined for short intensive periods of time, and in places far away from home, perhaps inevitably helped us make a creative and social bond with each other. This was often predicated on a common need for essential things such as food, warmth, safety, good humour and the provision of practical and emotional support. It was noticeable on the expedition to Disko Bay and the west coast of Greenland in 2008, for instance, that there was a collective dependence and willingness to co-validate each other's experiences of witnessing and participating in some of the most, dangerous, magnificent, hostile and inspiring places on this ever increasingly fragile planet. In particular, the ability to share recollections has allowed participants to maintain meaningful contact with each other and has been a crucial aspect of generating work for Unfold. The collaborations were fuelled both by a true sense of urgency and a real desire to bring the creative process back into the public domain, and to seek a broader engagement through various personally initiated projects, books, music, films, exhibitions etc and subsequent Cape Farewell events such as the SHIFT Festival, Southbank Centre, London, UK, January 2010 and the New Collaborations engagement programme of projects with arts universities.

When planning the Unfold exhibition we wanted it to have a 'flat pack' feel to both facilitate its compactness and touring profile in a manner that would minimise the carbon footprint of a world touring exhibition. We anticipated that, in addition to the core works in the exhibition, the various venues would select, or represent, local artists' contributions, and that they would undertake a responsibility for the public engagement with the work by organising workshops or related events around some of the issues. We also hoped, that where the exhibition is held in conjunction with arts universities, there would be a positive engagement that discusses the role and function of artists and creative practice in relation to climate and environmental issues and how these are reflected in research and curriculum development.

Finally we would both like to thank all the artists and participants in Unfold for their support, engagement and overwhelming generosity in working with Cape Farewell to create this influential body of work that addresses the important and urgent issues of climate change in a thoughtful, engaging and provocative manner.

David Buckland and Chris Wainwright

The Cape Farewell Project – A Cultural Response to Climate Change

It is clear that the consequences of climate change are real and very serious. But what is the true cause of this global change? It is not science that has caused the overheating planet but the way we have evolved our life-styles and values over the past 200 years. The excesses of our human activity coupled with our dependence on fossil fuels, which drive our econ-omies, is clearly not sustainable. We have become addicted to carbon to fuel our lifestyle and like all addictions, withdrawal will be physically, intellec-tually and emotionally challenging.

Over hundreds of millennia, the Earth's natural systems have been carefully sequestrating excess CO_2 deep underground in the form of oil, coal, gas and frozen methane. Human expansion and wealth over the past 200 years has been totally dependent on burning this resource to produce 'free' energy to fuel runaway popula-tion growth and activity. It is now established that the activity of six billion human beings leading a pollu-ting lifestyle has the capability to seriously damage the very thin twenty miles of atmosphere on which we are dependent for life. We are, as Ian McEwan aptly puts it, 'spoiling our nest' on an epic scale.

We have the technology to create non-polluting energy, but the cost investment has to be figured into new economic and cultural structures. Because the way we live is the root cause of climate change, a sense of cultural responsibility has the potential to deliver new and exciting horizons.

The Cape Farewell project was created ten years ago with a mission to make a major contribution towards creating a paradigm shift in the way that society perceives and responds to climate change. Currently as a society we view climate change from the perspective of looking down the wrong end of a telescope. It is a reality we observe from the distance of intellectual safety and only when we reach a position where we inhabit this reality will we truly engage with change. There is a need to shift our mental and physical state from observation to habitation. This is artistic territory; it is what artists do – they uncover the hidden, the unpalat-able, the unstated, whether it be in love, ethics or values, and it is this artistic skill that is the challenge of the Cape Farewell project. We ask the artists to engage their fine-tuned antennae to carve a vision where we can all inhabit, rather than just observe, the challenge of climate change and have the chance to perceive and create a different future.

Working internationally, Cape Farewell has brought together artists, scientists and communicators to stimu-late and cross-fertilise each other's practice to create a symbiotic depen-dency. The aim is to create artworks, writings and poetry; this is a two-way dialogue that has also shifted the scientist. The mode of enquiry of the artist and scientist has proven remark-ably similar; the climate challenge has brought the two tribes together to inhabit a territory largely forgotten in recent history. Using creativity to innovate and the act of doing as a means of research, the artists and the scientists have evolved and amplified their creative language to communicate on a human scale the urgency of the global climate chal-lenge. Since 2003, Cape Farewell has led seven expeditions to the High Arctic, and one expedition to the Andes, another major climate tipping point. Working with scientists these exped-itions have allowed the artists to gain a full understanding of the impli-cations of human activity on the fragile environment that is our planet. Over seventy artists from different disciplines have voyaged with us, including the novelists Ian McEwan, Vikram Seth and Yann Martel; the musicians Ryuichi Sakamoto, Jarvis Cocker, Laurie Anderson and Leslie Feist; the visual artists Antony Gormley, Gary Hume, Sophie Calle and Rachel Whiteread; architects Sunand Prasad and Peter Clegg; beatboxer Shlomo; and comedian Marcus Brigstocke to name just a few.

These amazing international artists have accepted the challenge to journey into this inspiring arctic desert of melting ice and mind-numbing cold and to the dank heat of the rainforests of Amazonia. They have found as much inspiration in the interaction with scientists and the other crewmembers as in the awe-inspiring landscape. On the return to their urban lives and studios both the science and art communities have worked together to create and make inspiring artworks, music, architecture and writings that will go towards achieving the cultural shift necessary to embrace a sustain-able global society for the future.

Each artist who has been part of the Cape Farewell expeditions has found a voice that, when unpacked, deals in some way with climate change. They have uniquely added to a new bank of ideas and imagery that brings the subject into a human scale and focus.

At the Royal Academy of Arts, London, December 2009, there was the exhibition Earth: Art of a Changing World, co-curated by Kathleen Soriano, Director of Exhibi-tions and myself. It brought together thirty-two artists, all addressing, in their own idiosyncratic dialogues, a cultural response to the way human activity is affecting the natural balance and physical cycles of our home,

Earth. It opened just before the Copenhagen Climate Conference and attracted a mountain of international press and over 25 000 visitors.

In January 2010 Cape Farewell launched the SHIFT Festival, in partnership with Southbank Centre, London, including concerts, discussions, video projections, fashion events and artworks. This partnership extended to London College of Fashion, University of the Arts London, University College Falmouth and the Eden Project, Cornwall, UK. There were two concerts. One was selected and hosted by comedian Marcus Brigstocke and included him in conversation with Ed Miliband, Secretary of State for Energy and Climate Change. There were performances by beatbox artist Shlomo, poet Lemn Sissay and musician Liam Frost. The second concert was selected and hosted by musician Robyn Hitchcock and included Graham Coxon, Kathryn Williams and KT Tunstall.

In the three SHIFT Encounters, Royal Festival Hall, London in January 2010, the public engaging with specialists in discussing climate change were firstly, architects Sunand Prasad, Peter Clegg and Sarah Wigglesworth; secondly, scientists Professor John Beddington, Chief Scientific Adviser to the UK Government, Professor Chris Rapley, Director, National History Museum, London and Dr Simon Boxall, University of Southampton, National Oceanographic Centre; and thirdly, artists Chris Wainwright, Jude Kelly, OBE Artistic Director of Southbank Centre, myself and Michèle Noach. The SHIFT Festival was a bringing together of creative and scientific communities in a unique event focusing on climate change, all of which was filmed for further audience engagement through various media including YouTube.

Historically, whenever there is a cultural shift, you will find artists working, thriving on the mobility and fluidity of human change. All Cape Farewell's work is just that: artists' immediate and uniquely creative response to what is arguably the greatest challenge humankind has ever faced. More importantly, it is a future truth and never before have our political leaders, economists and culture as a whole had to address such a proven truth waiting to happen.

It is too early to say whether this artistic activity foreshadows a shift of who and what the artist is in society. It is becoming clear though that a human cultural shift in priorities is required if we are to address the problems facing our overheating planet. This cultural shift necessitates worldwide engagement, and the goal would be a new and exciting cultural and economic horizon.

Cape Farewell resists a didactic approach, preferring to invest in artists who produce personal and emotively charged responses to climate change. These artists invite audiences to imagine their own relationship with climate change in a way that encourages fascination, curiosity, empathy, intellectual stimulation and the aspiration for behavioural change.

David Buckland
Founder and Director of Cape Farewell

I consider myself responsible to the coming generations, which are left stranded in a blitzed world, unaware of the soul trembling in awe before the mystery of life.

Oskar Kokoschka

Art, Science and the Universities in an Age of Climate Change – A Parallel Approach

'How is it possible that when we see a living horse, a dog, or a lion, this does not awaken feelings of wonderment within us and we are not delighted by their beauty; but when we view a picture of a horse, a bull, a flower, a bird, or a man, or even a fly, a worm, a stable fly, or another unpleasant creature, we are moved by the sight of such images and hold them in great esteem? What is the reason? Can it be traced back to the fact that in pictures we do not admire physical beauty, but rather the intellectual beauty of their creators.' (From a letter by the Byzantine humanist, Manuel Chrysoloras (1353–1415), quoted in *Kunstforum International*, Issue 93, Cologne 1988).

What Chrysoloras describes somewhat melodramatically is actually a major factor in both the reception and also the social influence of art. Images are frequently more powerful than reality itself; hence the fact that throughout history, art has been regarded by the powerful as being potentially dangerous, or at the very least, unreliable and suspicious. When realities or facts emerge from their 'normal' and familiar surroundings and are placed in another context, they suddenly gain fresh regard and significance. In fact it is the ideas behind the artistic act of transformation and translocation of realities, which find the recognition and significance that Chrysoloras describes in the spirit of his age as the 'intellectual beauty' of the originator.

Adorno wrote that, 'Art is magic, liberated from the lie of being the truth.' People have been confronted with lies that stake a claim to truth throughout time and in any number of social forms. Political and religious leaders promulgate disguised messages as truths and thereby trust in the forgetfulness or defeatism of the population. Industrial strategists arouse expectations, hopes and/or fears through announcements and expertise adorned with the aura of truth. They thus control share prices, consumer behaviour and even entire political systems, and last, but by no means least, impacts on the very status of our natural environment. Art exists in a dimension that is beyond truth and falsehood. However, with this approach does art not adopt a position outside of social reality? Moreover, if art regards itself as being free of a claim to truth, does it not also remove itself from the fabric of social development and influence? Or could it be the case as readily suggested by the history of art and artistic persecution, which continues even today, that due precisely to this intentional severance from a dogmatic claim to truth, or let us say empirical verity, art first achieves validity and effectiveness in a society in which so many calumnies are uttered in the name of truth, goodness and beauty?

'Climate change is a reality. Caused by us all, it is a cultural, social and economic problem and must move beyond scientific debate. Each artist who has been part of the Cape Farewell expeditions has found a voice that, when unpacked, deals in some way with climate change. Each has uniquely added to a new bank of ideas and imagery that brings the subject of climate change into focus on a human scale.' This is how David Buckland describes the fundamental idea behind Cape Farewell, 'an interdisciplinary initiative, which constitutes a cultural response to climate change'.

Precisely because 'pictures' and art are more powerful than that which we recognise as 'reality', it would seem to be especially worthwhile to help communicate the facts and figures relating to global climate change, which are substantiated by scientific knowledge, by the means of art and thus promote problem awareness and a readiness to take socio-political action beyond expert circles. However, even more is at stake because art and art institutions always were and remain some of the most powerful breeding grounds for critical analysis, social utopias and the will to contribute to a life full of meaning, empathy, social consideration, thoughtfulness, innovation and creativity, rather than shallow technocratic indifference.

The example of climate change and its manifold causes makes clear, in both a crushing and equally hopeful manner, that sustainable solutions can only be achieved by means of holistic approaches, which traverse ideological, system-endemic and disciplinary limitations. The belief that economic growth and technical progress can be uncoupled from cultural, ecological and also social questions generates the unbalances for which climate change is merely a proxy.

Art and science can and must reveal the injurious and dangerous structures created when people and nature are solely regarded as human capital or a source of raw materials, while the economy is allotted the status of a stand-alone, politically untouchable dimension. Every person acting with a sense of eco-social responsibility must raise questions concerning personal accountability, our individual actions, handling of resources and energy, and nutritional, housing and mobility habits. Changes and paradigmatic shifts are the result of autonomous, networked initiatives, which finally expand to a degree that makes political reaction unavoidable. A living

society is characterised by the strengthening of these initiatives with energy, innovative spirit, well-founded facts and figures and creative ideas relating to implementation. And it is precisely these attributes, which our world needs to overcome current challenges, that art and science can provide.

However, art is not purely an instrument of social communication. In fact, a growing number of scientists and artists have established that when confronted by the need to pursue new paths, conquer additional scientific or aesthetic 'worlds' and create new realities, the greater the similarities become between the methods and strategies employed in both artistic and scientific research and development. Therefore, the increasing complexity of the issues relating to our social, economic and natural environment strongly suggests the probity of synergetic teamwork between science and the arts, even if academic traditions and the university power and career mechanisms still place a powerful damper on the realisation of such integrative strategies.

We are all familiar with the distorted image of the universities as ivory towers in which research takes place in isolation and freedom. And in truth, these bastions not only still exist but today are actually multiplying. However, it is no longer the universities that constitute the ivory towers, but rather the individual researchers themselves. As a scientist or artist, one must be clearly classifiable within the system, in order to survive in the competition for attention and funding. Accordingly, an interdisciplinary approach continues to be seen mainly as a luxury or a quirk, which has little in common with 'serious' scientific work. Therefore, although it is evident that the mastery of the real issues of the 21st century will only be possible through the interplay of various scientific disciplines and the synergetic networking of apparently independent specialist areas, the lone wolf principle continues to predominate within the scientific community. An idea inspired by the romantic concept of the genius.

One should not denigrate personal achievements, as these will and should continue to exist. However, the issue at stake is whether a cultural transformation can be initiated in the scientific, not to mention the artistic, community that no longer focuses upon the isolated publications of individual researchers, but leads to project-oriented, interdisciplinary working and transdisciplinarity as the paramount guideline for inventive activity. Such a cultural shift would also define success through a focus on other integrative parameters rather than performance in the art market. All of these aspects have consequences for the study of architecture, research support programmes and linguistic culture. Communication mechanisms have to be created between the representatives of various disciplines and semantic and methodological walls must be torn down. The matter in hand is the shaping of universities as an antithesis to disciplinary fragmentation and scientific and artistic isolation or, in other words, universities as central institutions for socio-cultural development. The participation of several leading art schools such Columbia College Chicago, Camberwell, Chelsea and Wimbledon Colleges (CCW) and the University of Applied Arts Vienna in this Cape Farewell exhibition project constitutes an important signpost in this direction.

Art and science are similar to an extent that is both frightening and heartening. Therefore, neither of them should fall prey to the frequently overwhelming temptation to simply please. This is because the arts and science are both litmus papers and correctives with regard to 'social acidity levels', i.e. the apathy of societies towards their members and environments. In order to fulfil their social roles, science and the arts should never be pretty, cuddly, entertaining, amusing, decorative or aesthetic for aestheticism's sake. The true beauty of art lies in its ability to move us intellectually, motivate us to follow new paths, shape awareness and character, demonstrate interconnections and teach us to employ all the things that surround us in a conscious manner. The achievement of social effectiveness can neither be the aim nor the purpose of art. Nonetheless, art *has* a social influence, either in the sense of change, or in the spirit of affirmation and conservation.

Walter Benjamin once demanded that: 'Art be the governor of Utopia.' And although demands do not constitute reality, they do possess the power to shape it.

Dr Gerald Bast
Rector, University of Applied Arts Vienna

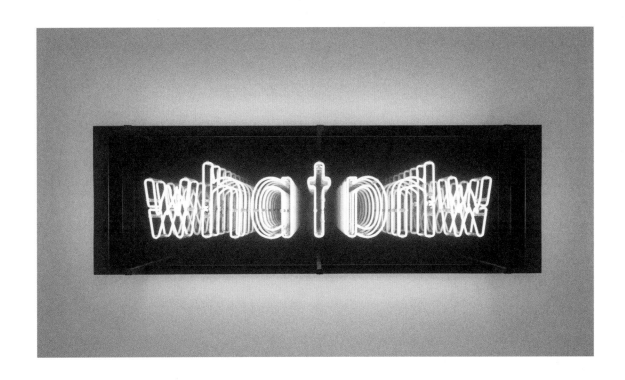

Brigitte Kowanz
WHAT
Neon light on mirror
2000
Photo by Peter Kainz/faksimile digital

Energy, Climate, Humans

Human beings are the dominant creatures on Earth. We have shaped the world to suit our needs. Through agriculture and engineering we have assured our supplies of food and water, and through the development of society and culture we have gained the possibility of secure and rewarding lives. Progress has taken place at an accelerating rate, the dizzying burst of industrialisation that shaped the modern world taking a mere hundred years. The upshot is an interconnected and technology driven global society, a human population of 6.5 billion, and our ability to contemplate ourselves and the universe with insight and wonder, based on fact rather than fable.

Two key factors have underpinned this stunning success story: the recent unusual stability of global climate patterns, and the discovery and exploitation of cheap sources of concentrated energy, namely, coal, oil and natural gas. It is tempting to assume that our progress and growth can continue indefinitely, and economists and politicians generally do just that. But on a planet with a history of climatic variability that has often witnessed rapid instability, this is not necessarily the case.

Early in the industrial age such scientist-thinkers as Joseph Fourier and John Tyndall pondered the consequences of the massive burning of carbon-based fuels. They understood that the presence in the atmosphere of water vapour, carbon dioxide and other minor constituents warms the surface of the Earth, allowing life as we know it to exist and prosper. They reasoned that by increasing the atmospheric concentration of greenhouse gases, we would increase the warming process.

Measurements taken of air that has been trapped for millennia in Antarctic ice show that in constructing and operating the modern world we have dramatically increased the carbon-dioxide content of the atmosphere. We have done so by an amount as great as the natural change between an ice age and an interglacial age, and at a rate almost one hundred times as fast. The current state of the atmosphere resembles that of 30 million years ago, before Antarctica was covered with ice. And we can detect the resultant enhanced warming.

Surface temperatures have increased by 0.75 degrees Celsius since pre-industrial times, which has had an impact on the distribution of plant systems and ice cover. Of the last thirteen years, eleven have been the warmest since records began. The global mean sea level, which had been stable for several thousand years, has begun to rise, both as the water warms and expands, and because of an inflow from the melting of land-based ice. The overall pattern of results is compelling, leading the Science Academies of America, Brazil, Canada, China, France, Germany, India, Italy, Japan, Russia and the United Kingdom to conclude: there is now strong evidence that significant global warming is occurring. It is likely that most of the warming in recent decades can be attributed to human activities. This warming has already led to changes in the Earth's climate.

So what will be the consequences? Scientists calculate that of the warming that we have already incurred, only half has taken effect so far. And they reason that if carbon-dioxide emissions continue unabated, we face an increasing risk of disruptive climatic changes capable of impacting on food and water supplies, with repercussions for each of us. A warming of four degrees or more would be truly threatening, with the potential to undermine world stability.

Why is it that we are so vulnerable? After all, the Earth's climate has varied greatly in the past, and life has adapted and flourished. Evolution provides the answer. The fittest survive because they are most able to adapt. But the design of our modern world is tightly tied to the climate system as we found it. Changed patterns of temperature and rainfall may exceed our capacity to adapt and an unstable climate system could be incapable of supporting humans in our current numbers. Indeed, each of us is trapped in an iron cage, utterly dependent on existing brittle human systems to provide all that we need in order to live.

At some point in the last year, unmarked by ceremony, humanity released into the atmosphere the carbon dioxide from the half-trillionth ton of coal, oil and gas it has burned. In order to have a fifty-per-cent chance of keeping global warming below two degrees Celsius, and thereby limit the threat of damaging climate change, it is estimated that of the remaining carbon, we can burn at most another 0.5 trillion tons. At the rate at which we are burning carbon today, this will occur some time in the decade between 2040 and 2050. This limit is lower than the readily accessible reserves of coal, oil and gas, so we must take collective action to shift away from carbon-intensive energy supplies and agriculture, both by developing new technologies and by changing the way we live. The later we leave it, the more costly and difficult the shift will be.

This is why negotiations at the United Nations Climate Change Conference in Copenhagen in December 2009, and beyond, are critical. This is why the world needs a deal that will guarantee human carbon emissions peaking and declining soon, so that the trillionth ton is not released

into the atmosphere. This is why it is crucial to engage people with the issue and confront the possibilities – both the threats and the opportunities. This is why the words of John F. Kennedy have never been more relevant: 'Our problems are man-made, therefore they may be solved by man.'

Professor Chris Rapley CBE
Director of the Science Museum, London and Professor of Climate Science at University College London

With the exception of solar energy, all materials and energy used on this earth are supplied by the global ecosystem, and all materials used are either recycled or they become wastes and pollutants that are disposed into the global ecosystem; the energy is dissipated as unusable heat (Meadows et al 2004). Human society and its economic system are sub-systems of the global ecosystem.

Greenhouse gases, especially carbon dioxide (CO_2), are one type of 'waste' introduced into the system, more precisely the atmosphere, and they are introduced at a rate exceeding the capacity of the global ecosystem to stabilise and are thus disturbing the global radiation balance and inducing a change of global climate. CO_2 concentrations in the atmosphere have undergone considerable changes through the ages, but over the last 600 000 years they have varied in a cyclic manner between roughly 180 and 280 ppm. These changes were driven by changes in the radiative input from the sun and the ensuing temperature changes that influenced biomass production, thawing and freezing of permafrost, CO_2 storage or release in the upper layers of the oceans, etc. The feedback mechanisms linking CO_2 concentrations to temperature cause an extremely high correlation between these two factors.

With the increasing use of coal, oil and gas as a source of cheap and originally seemingly inexhaustible energy, CO_2 concentrations in the atmosphere have accumulated to more than 380 ppm in 2008 (or 430 ppm CO_2 equivalents if all GHGs are considered). In consequence, a higher percentage of solar radiation is 'trapped' in the atmosphere, raising the temper-

ature in the climate system. Since pre-industrial times the average global temperature has risen by about 0.8°C. The temperatures presently experienced are the highest in the last 1000 years. If greenhouse gas emissions continue at the same rate, an increase of 4°C as compared to the period 1980–1999 must be expected by the end of the century. Taking uncertainties in climate modelling and present rates of GHG emissions into account, this figure could rise to 6.4°C. But climate change is not restricted to temperature changes. All other climate parameters are also affected: averages, seasonal and frequency distributions, and extreme events are changing. (IPCC 2007)

At the regional and local level climate change can deviate considerably from global averages. Thus temperature rise in Austria is significantly higher than in the global mean and is expected to reach 1.8 to 4°C as early as the middle of the century. Temperature rise is especially pronounced in the polar region of the northern hemisphere, where the melting of arctic sea ice in the summer months is one very visible effect of ongoing climate change. As compared to the minimum ice extent in the summers of the period 1979–2005, about 40% of the ice surface was lost in the summers of 2007 and 2008. This has opened the North-West passage to transport and it has raised hopes for easier access to resources on the sea floor in the Arctic, but, more importantly, it has reduced the reflectivity of the Arctic and thus increased absorption of solar radiation, leading to further temperature increase and more melting – a positive feedback mechanism that could be a major contributor to the unexpected increase in the speed of climate change.

If global temperature rises by more than 2°C as compared to the pre-industrial level, there is concern that 'tipping points' might be reached that either lead to strong positive feed-back loops enhancing climate change or to damages of such extent that humanity cannot deal with them (Lenton et al. 2008). The need for action is obvious and there is global political agreement that temperature rise beyond 2°C within this century must be prevented.

To achieve this, mitigation measures that dramatically and rapidly reduce GHG emissions are needed: no more than an additional 750 Gt of CO_2 must be introduced into the atmosphere. This limit would be reached if all the reserves of conventional oil and gas were exploited and used and coal was completely phased out by 2025. Emissions would need to drop from the 10 to 20 t of CO_2 per person a year in the industrialised world to about 1 t of CO_2 per person a year.

In view of this daunting task the question arises whether there are other solutions? The option originally favoured by many economists was to just adapt to climate change. However, since the publication of the Stern Report 2006 it is generally accepted that adaptation is more expensive than mitigation in the long run. There are also limits to adaptability. In any case adaptation to those changes that can not be prevented will be necessary and is already ongoing.

Other options strongly propagated by some are of a technological nature: geo-engineering solutions, such as Paul Crutzen's suggestion to introduce sulphate aerosols into the stratosphere to reflect some of the short wave solar radiation or carbon capture and storage (CCS) in the deep ocean or in depleted oil and gas reservoirs involve unproven technologies and risks that have not been properly assessed.

More importantly, these options address only the climate problem that – important though it is – must be seen as just one symptom of a deeper underlying problem: the overuse of resources. In 'Limits to Growth' Meadows et al. (1972) pointed out that in a confined system exponential growth leads to overshooting and then to the collapse of the system. Recently, Rockström et al. (2009) showed that humanity has left the safe operating space of the planet in at least three of eight studied domains: climate change, the nitrogen cycle and biodiversity loss, with the phosphorus cycle very close to the limit. The global ecological footprint also indicates that 1.25 earths would be needed to make our present global resource use sustainable; the resource use in the industrialised world the world over would require 3 to 5 earths.

The impact of humanity on the global ecosystem can be described by a simple equation: Impact on the global ecosystem = Population × Affluence × Technology.

This relation (Kaya Identity or IPAT) shows that – other things remaining equal – exponential growth of population must lead to exponential increase of environmental impact. Rising affluence – a goal of globalisation and the free market economy and even part of the Millennium Goals – will add another significant increase to the impact on the ecosystem. The only factor possibly counteracting this ongoing development is technology: only if technological improvements can decrease the use of resources with sufficient speed to balance the increase in the other two factors will the impact at least remain constant.

From this point of view the emphasis presently placed on technological innovation in the climate change debate appears legitimate. However, the hope that technological improve-

ments could occur fast enough to stabilise or even reduce the impact of a 6.5 billion population expected to reach 9 billion by the middle of this century, billions that individually claim more resources year by year, is not justified. History shows that for several reasons technological development has generally led to the use of more, not less resources (energy, water, food, materials, etc.). Through the rebound effect even efficiency increase has frequently stimulated higher consumption of, for example, energy.

Thus it becomes increasingly clear that the development of the world population and of affluence must also be addressed, if impacts on the global ecosystem are to be reduced. The last requires deep structural and societal changes: a cultural change or the 'end of the world as we knew it' (Leggewie and Welzer 2009). This can be seen as an enormous opportunity, because what may appear to require doing without could prove to lead to an increased quality of life.

But how can democratic societies overcome the strong structural and psychological obstacles to the necessary changes? Possibly only through individuals and societies taking on more responsibility. Traditional values need to be reviewed regarding their affordability – e.g. compound interest or quantitative economic growth – and more long-term thinking needs to be restored (Diamond 2005). Only with public support will politicians be able to change the rules of the financial, economic and political game in a manner that will make sustainability an integral part of success. Rather than wait for the lifestyle changes nature will impose on us, we should set out to shape them to meet the requirements of humanity and nature.

Helga Kromp-Kolb
Institute of Meteorology, BOKU,
University of Natural Resources and
Applied Life Sciences, Vienna, Austria

References

Crutzen, P. (2006) 'Albedo enhancement by stratospheric sulfur injections: A contribution to resolve a policy dilemna? An editorial essay'. *Climatic Change* 77: 211–19

Diamond, Jared (2005) *Collapse: How Societies Choose to Fail or Succeed*. Penguin Books

IPCC (2007) 'Climate change 2007: The physical science basis summary for policymakers'. Contribution of Working Group I to the Fourth Assessment Report of the Intergovernmental Panel on Climate Change. IPCC secretariat, Geneva. www.ipcc.ch

Leggewie, C. and H. Welzer (2009) *Das Ende der Welt, wie wir sie kannten: Klima, Zukunft und die Chancen der Demokratie*. S. Fischer Verlag, Frankfurt am Main

Lenton, Timothy M., Hermann Held, Elmar Kriegler, Jim W. Hall, Wolfgang Lucht, Stefan Rahmstorf and Hans Joachim Schellnhuber (2008) 'Tipping elements in the Earth's climate system', *PNAS* 105 (6), pp.1786–1793

Meadows, Dennis, Donella Meadows, E. Zahn, P. Milling (1972) *Grenzen des Wachstums: Bericht des Club of Rome zur Lage der Menschheit*. Deutsche Verlagsanstalt GmbH, Stuttgart

Meadows, Donella, J. Randers and Dennis Meadows (2004) *Limits to Growth: The 30-year update*. Chelsea Green Publishing Company, White River Junction, Vermont

Stern (2006) 'Stern Review: The economics of climate change'. www.hm-treasury.gov.uk/Independent_Reviews/stern_review_economics_climate_change/sternreview_index.c (access date: 23 October 2006)

Rockström, J. et al. (2009) 'A safe operating space for humanity'. *Nature* 461: 7263, 24 September 2009, p.472

Art and Action

Most of what we call great art is associated with disaster after the fact. The artists respond to the passing of *The Four Horsemen of the Apocalypse* (*Revelation*, chapter 6, verses 1–8) and speculate directly or metaphorically about how things could or should be different to avoid similar events or situations in the future. Consider, for example, the motivations behind Homer's *The Iliad*, 8th century BC, Gericault's *The Raft of the Medusa*, 1818–1819, Stephen Crane's *The Red Badge of Courage*, 1895, Lewis Milestone's film *All Quiet on the Western Front*, 1930 and Ernest Hemingway's semi autobiographical novel *A Farewell to Arms*, 1929. Mike Kelly's installation *Pay for Your Pleasure*, 1988, at The Renaissance Society, The University of Chicago, contains imagery and quotes from a large group of writers and plastic artists attesting to the fact that art usually follows and refers to horrific events: conquest, war, famine, death.

Secondly, a smaller group of artists is heard in the middle of existing and evolving disasters – smaller because their views often go counter to the majority. Their warnings and descriptions are generally open, but they can also develop elaborate coded responses that disguise their intentions if need be. The artists included in Hitler's Degenerate Art exhibition, Munich, Germany, 1937, were perceived, rightly, as a danger to the rise of National Socialism and the exhibits were intended to expose and disarm their often-coded critique. Another example is Arthur Miller's play *The Crucible*, 1953. The play, based on historic witch hunts in New England, was a clear and negative take on the House Un-american Activities Committee, 1938–1975, and the national hysteria about Communism of the time. Parallel to the art critical of Nazism being confiscated by Hitler, Arthur Miller was blacklisted as a writer along with many others. Art commenting about bad times, in the middle of bad times, can be very unpopular.

The artists of the Cape Farewell project are in a third group in that the environmental disasters they are referring to are yet to come, even though the time predictions get shorter and shorter. There is clearly something happening to the planet now, and it is more or less clear that we humans are causing it. When things will completely fall apart into the Four Horsemen categories is not that clear, and, to paraphrase T.S. Eliot, it might end with more of a whimper than a bang. And, to make their job as contemporary artists more difficult, they don't have Shelley's sonnet *Ozymandias*, 1818, a wrecked symbol of collapsed power in an antique land to remind them of the potential trajectory of their own cultural failure. To make matters worse, it is fairly disheartening to create warning metaphors involving not just the death of a culture but the death of a planet. It is hard to keep an audience focused on such things.

We humans are prone to pointing out that long term disasters are going to happen after we are dead so why worry about it. The next generation won't take us seriously anyway. Why take the trouble to compose an *Iliad* when the next generation, having forgotten the story, will head for war no matter what? In his introductory remarks David Buckland defines the mission of The Cape Farewell Project as, 'to make a major contribution towards creating a paradigm shift in the way society perceives and responds to climate change'. The artists involved in the project have a burden/goal of being effective prophets, not relaxed harbingers, as Buckland goes on to imply.

The history of art can be seen as a series of peaks and valleys, an extended sine wave, moving from great confidence to great pessimism that art can change the direction of culture. During the last depression, most of the photographers working for the Farm Security Administration, History Section, firmly believed that if they recorded the effects of economic collapse carefully enough, remedies would be found and implemented and things would turn around. Most of these people were artists enlisted to be social documentarians. Less than twenty years later, the American abstract expressionist painters had absolutely no similar confidence and turned almost entirely inward to try to change themselves rather than the world.

The Cape Farewell artists seem to me to be trying to break out of this pattern. They are well aware that a high percentage of the people in the world are living in poverty and using up all of the resources they can find to survive. So that seems hopeless. On the other hand, they are aware that even those of us who consider ourselves enlightened in matters of climate change are doing more than our part to waste the planet's resources and could be persuaded to do otherwise, metaphorically or directly. How many of us have noticed that our cities no longer have night hawks swooping around at dusk? How many of us stare out the plane window in disbelief at the layer of reddish smog that now seems to be everywhere? How many of us have noticed that ninety-nine per cent of the farms we pass in the Midwest no longer have any animals or crop diversity – just genetically modified soya beans and corn? How many of us have seen the glaciers of

the Columbia Ice Field along the Banff/Jasper highway disappear over the hill? (Michèle Noach's Norwegian glacier project deals with this directly). These and many similar phenomena have all happened in one lifetime – mine.

This personal level of engagement with the primary and secondary causes and effects of global climate change sets up a potential for engaging and productive dialogue, and the Cape Farewell people have done well to bring scientists and artists together to take advantage of it. When I was a student at the University of Iowa in the early 1960s a group of us studying writing and literature frequented the same bar as the group that worked with Dr James Van Allen on atmospheric studies. I quickly learned that experimental science and experimental literature use very similar inventive strategies. The Cape Farewell artists, as can be seen in Unfold, have not been shy about appropriating the accoutrements, equipment and intellectual structures of science.

Art, to be effective, usually gains strength from indirection. Often, however counter intuitively, it is harder to see the truth of something if you are staring straight at it. Indirection is even harder to accomplish and control when standing on a pile of concrete evidence, and listening to experts explain it, as these artists have been invited to do by Cape Farewell. This has pushed them into some very interesting creative territory. In addition, they have been invited to explain themselves in writing, a very contemporary practice in contrast to the mute art of the past where explanation was tantamount to the invasion of the artist's soul. The stakes are too high for that here. The point of view is us and them standing side by side.

Nick Edwards' project, *Expedition to the Source of the Dollis Brook in search of the Consequences of the Ideas of the Sublime and the Beautiful*, explores, in part, another potential barrier to making art about climate change created by us. Nature, writ large, has for most of the human history of making art, been seen as immutable in its eternal cycles, especially cycles of regeneration. The Hudson River School of painters in the mid 19th century downplayed the fact that the unspoiled wilderness was fast receding in front of settlement and agriculture. This made it easier for them to refer to the wild as the cathedral of the New World. They usually portrayed people as small and helpless in the face of nature. The descendants of these painters now go to Yosemite and make striking photographs of ancient, seemingly permanent stone batholiths, forgetting that they are standing in a tiny fraction of western America, a miniscule token of Nature. The notion of the Sublime is capable of destroying our concept of space and time. The allied notion of the Beautiful is capable of making us blind. Being safely handcuffed to both these artistic behemoths makes it almost impossible to consider that we may be responsible for the decline and death of our planet.

One effective way to avoid the pitfalls of traditional art and art venues – their tendency to abstract and sterilize art-produced ideas – is to directly engage and activate the viewer. Alfredo Jaar, the contemporary Chilean artist, is well known for refusing to mount labels or wall texts when he shows his work in museums. His rationale is that people will read about his images, for example the dumping of barrels of chemical waste on the coast of Africa by European companies, be horrified and move on to something else. He would prefer

that the audience come to a lecture by him or that guards be trained to explain what is going on in the exhibition. He is more confident in direct human contact as a way to get people to act on their horror. Several of the Unfold artists have chosen not to rely on captions. Others, like Daro Montag require the action of the viewer to be complete. Presumably, after burying the charcoal acquired on line, the viewer will be able to more readily monitor his or her own waste of natural resources having been presented with a metaphoric example of good behavior.

The encoding of activist art spoken of earlier is used in a playful way – a savvy relief in this serious intellectual environment – in the work by Chris Wainwright, *Here Comes the Sun, There Goes the Ice*. Here the encoding is meant to alert the viewer, however, not hide the motives of the artist from a conservative public. The light signals, hand held by Robyn Hitchcock, are quickly associated with airline ground workers letting pilots know when they are safe and when not as they are manoeuvring on the runway. We are not privy to the meaning of those gestures, but we are prone to shifting into questioning mode. Some of us might also associate the signals with the coded messaging from one warship to another during radio silence. This range from jeopardy to ignorance sets us up for wanting to know more about the poetically stated subject of the piece. This project might be thought of as a null, set in the rich and complex totality of Cape Farewell. It gets us back to zero so we can start anew.

In his interview with David Buckland, published here in Unfold, Chris Wainwright points out that we can talk about climate change from a lot of different viewpoints except when we are in the Arctic, actually seeing the

glaciers losing tons of ice at an increased and alarming rate. There we are forced into a situation well known to artists where we can only think about one thing in disconcerting depth. It is enlightening to juxtapose this idea with the video piece by Amy Balkin, *Summary for Policymakers*. Here we are confronted with way too much information, much of which is in a technical language most of us don't understand. This might ideally cause us to crave a simpler and direct warning and creates a polar opposite (pardon the pun) to the Wainwright signal piece. Those of us in the arts community might also take this as a direct charge to figure out a path to inclusion and clarity of the climate change subject without going overboard on either end. And it might create a rare instance of art actually changing somebody's mind and causing them to act.

Rod Slemmons
Director, Museum of Contemporary
Photography, Columbia College
Chicago

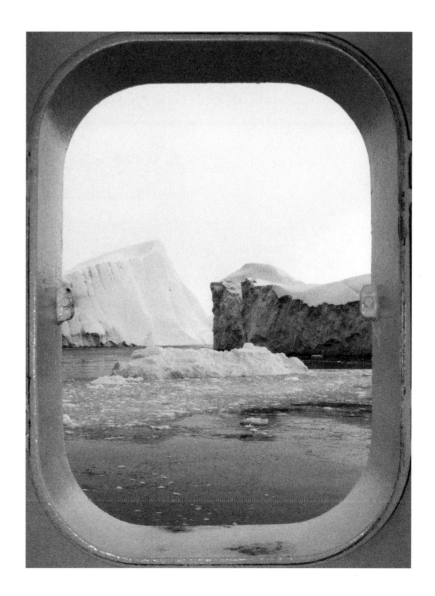

Ackroyd & Harvey

Storm Drawings

The challenge of making a visual diary that captured the unique experience of sailing through a remote part of the world preoccupied and inspired me. I experimented with various ways of recording our journey from Svalbard to Greenland: eroding suspended plaster blocks in the ocean behind the ship; burning card with a large lens that tracked the ship's movement in relation to the sun; allowing a small ball covered with ink to roll over paper soaked in seawater.

The journey from Svalbard to Greenland was calculated to take four or five days although weather warnings before we set sail indicated conditions weren't great and that there was a possibility that a huge area of sea ice had broken up in the Arctic Ocean and was being swept south by strong winds.

As it was, we arrived in Greenland after nine gruelling days of sailing. Although I had previously undertaken voyages with Cape Farewell and had developed 'sea legs', I don't think I, or any of us, were prepared for such a rough ride. The exhaustion, stress and fear were palpable.

I wanted to find an unpredictable way to document the wild bucking and rolling of the ship. The idea was to set up a tray that could contain an ink-soaked ball and allow this to roll backwards and forwards in reaction to the ship's erratic movements. Constructing a makeshift waterproof tray was relatively easy to do but trying to find a ball on the boat was not! Eventually, I found that some of the ship's light bulbs could be made into spheres by breaking the metal attachment off one end and removing the filament. I was able to fill the hollow with plaster, and when hard, crack and pick the glass off.

After trying various consistencies of ink, I realised that by soaking the paper in seawater first, the tracks that were left by the ball's movement became subtler and more evocative. The storm grew in intensity and as night fell we seemed to be in a very dark place. I had brought some luminous paint with me and, using the same set-up, produced another series of drawings that glowed with the same quality of light as the Northern Lights that shifted and flowed overhead, glimpsing very occasionally through cracks in the blackened sky.

Eventually the storm subsided and by dawn we finally saw the coast of Greenland – a truly beautiful sight! The storm had passed, the sky had cleared and the sun was rising, illuminating the most exquisite enormous icebergs I have ever seen. The sense of rebirth after one hell of a journey was intoxicating! We finally and gratefully made it to shore a few hours later.

Dan Harvey of artist partnership, Ackroyd & Harvey

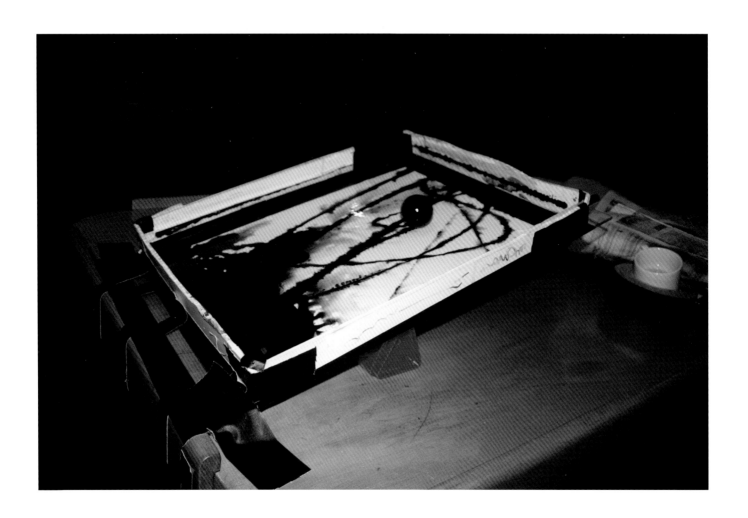

Making of *Storm Drawings*

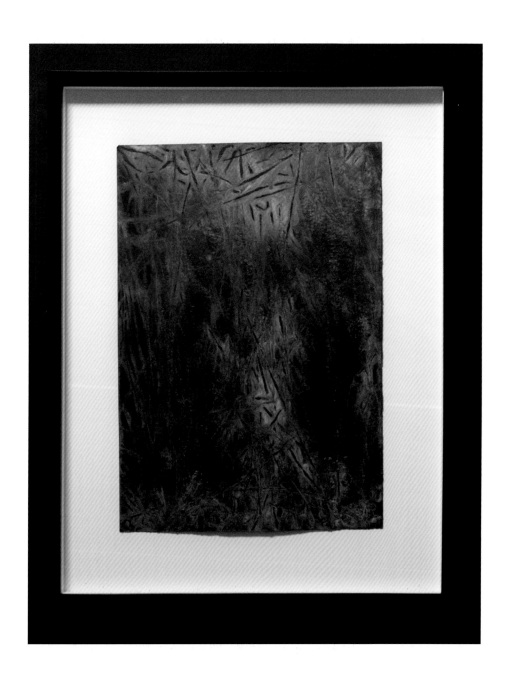

Storm Drawings
Luminescent paint on paper
57 × 45 cm
2007

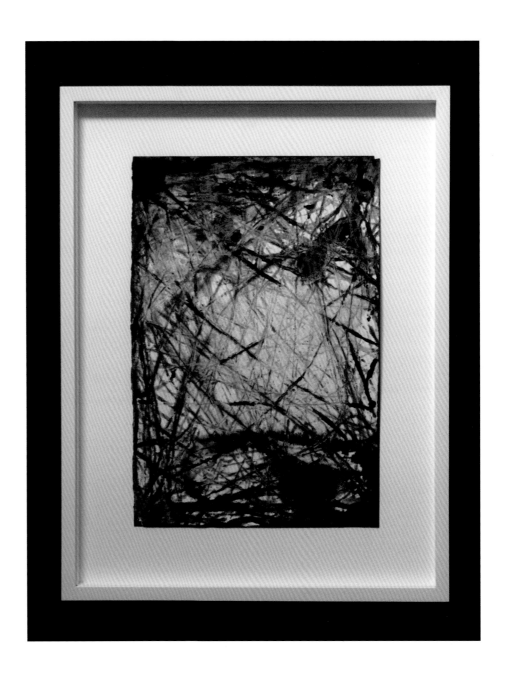

Storm Drawings
Ink on paper
57 × 45 cm
2007

Polar Diamond

The landscape of the High Arctic is almost bereft of trees, a place of ice and glaciers subject to unprecedented levels of warming and often referred to as 'the canary in the coal mine' of the climate crisis. Our work *Polar Diamond* was born out of the expedition to Svalbard Arctic Archipelago, 2004. The Environmental Manager at Svalbard showed us the leg bone of a polar bear that was kept in the building she worked in. When the necessary permissions were granted, we had the bone sent to us in the United Kingdom and we subsequently reduced it to carbon graphite in a cremation process. Using technology to accelerate a process that usually occurs naturally over millions of years, a diamond has been grown from the residue. The hardest substance found in nature, diamonds are composed of atoms of carbon, a chemical element that originated from the stars. Now, the cumulative carbon emissions from the burning of fossil fuels jeopardise many of the Earth's fragile ecosystems, including that of the Arctic.

In 2008, overwhelming scientific evidence of dwindling sea ice in the region and all scientific models showing that the rapid loss of ice will continue were key to the decision to place polar bears under the protection of the Endangered Species Act.

Polar Diamond carries an implicit pathos, an anticipation of loss, and the knowledge that rarity inevitably increases value. It poses the question, what price is paid for carbon?

Polar Diamond was realised with the support of Royal Academy of Arts, London.

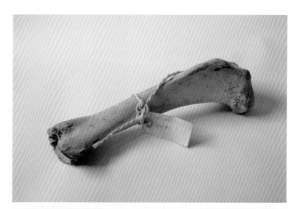

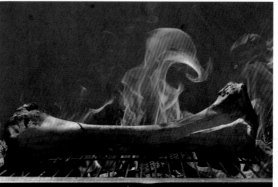

Making of *Polar Diamond*

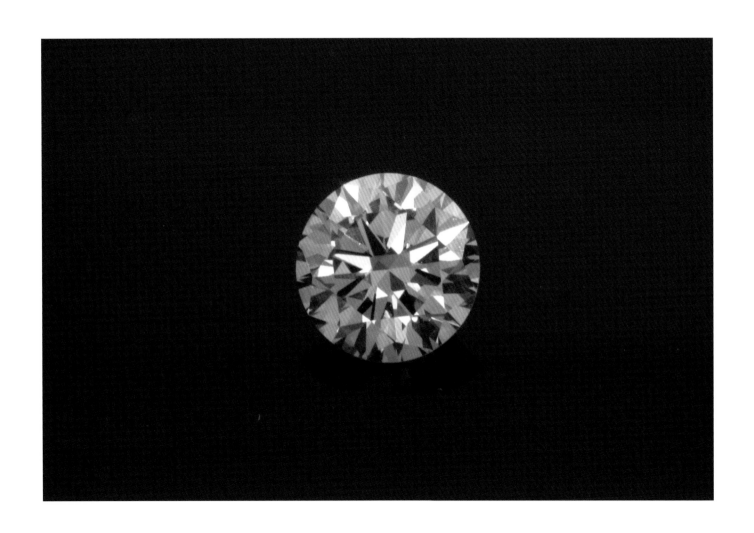

Polar Diamond
Diamond
5.34 – 5.37 × 3.20 mm
2009

<u>Amy Balkin</u>

Climate Change 2007: Synthesis Report
Summary for Policymakers

The *Summary for Policymakers* (SPM) is based on a draft prepared by: Lenny Bernstein, Peter Bosch, Osvaldo Canziani, Zhenlin Chen, Renate Christ, Ogunlade Davidson, William Hare, Saleemul Huq, David Karoly, Vladimir Kattsov, Zbigniew Kundzewicz, Jian Liu, Ulrike Lohmann, Martin Manning, Taroh Matsuno, Bettina Menne, Bert Metz, Monirul Mirza, Neville Nicholls, Leonard Nurse, Rajendra Pachauri, Jean Palutikof, Martin Parry, Dahe Qin, Nijavalli Ravindranath, Andy Reisinger, Jiawen Ren, Keywan Riahi, Cynthia Rosenzweig, Matilde Rusticucci, Stephen Schneider, Youba Sokona, Susan Solomon, Peter Stott, Ronald Stouffer, Taishi Sugiyama, Rob Swart, Dennis Tirpak, Coleen Vogel, Gary Yohe.

Over a period of 38 minutes, Amy Balkin reads the 'Summary for Policymakers for the Synthesis Report of the IPCC Fourth Assessment Report (AR4) on Climate Change Science.' Shot in one long take, the video reading addresses the intersection of climate change and questions of political participation.

The 'Synthesis Report' is the last instalment of the 'Fourth Assessment Report', the most recent report released by the IPCC, the Intergovernmental Panel on Climate Change. The previous three instalments examined the physical science basis for climate change, the impact of global climate change, and solutions to global climate change, particularly options for reducing greenhouse gas emissions.

The 'Summary for Policymakers' is a synopsis of the reports intended to aid policymakers. During the approval process, government delegations have the opportunity to make line-by-line changes to the summary, with approval from the Lead Authors.

In a related project, Balkin organised a participatory public attempt to read the 800-page 'Working Group III Report Mitigation of Climate Change' which took place in Manchester in 2009. The reading was for eight hours a day over three days, with fifty participants reading for twenty minutes each. Just over two hundred pages were read in total.

The report is available to download online from the IPCC website, yet remains somewhat inaccessible due to its length and specialist language. Here the text was read aloud, using the document as a meeting place where art audiences, climate activists and other citizens could interact and exchange.

The Pew Center on Global Climate Change, www.pewclimate.org/ipcc_ar4synthesis
IPCC Factsheet: How the Summary for Policymakers of an IPCC Working Group report is approved during the Plenary, www1.ipcc.ch/press/ar4-factsheet2.htm

Climate Change 2007: Synthesis Report –
Summary for Policymakers
Video, 38 min 53 sec
2008

Climate Change 2007:
Synthesis Report

Summary for Policymakers

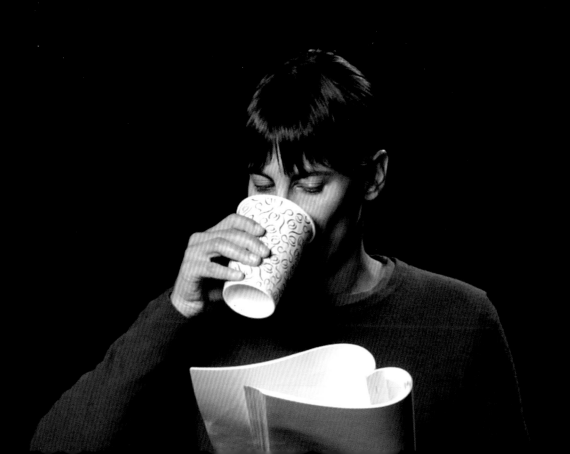

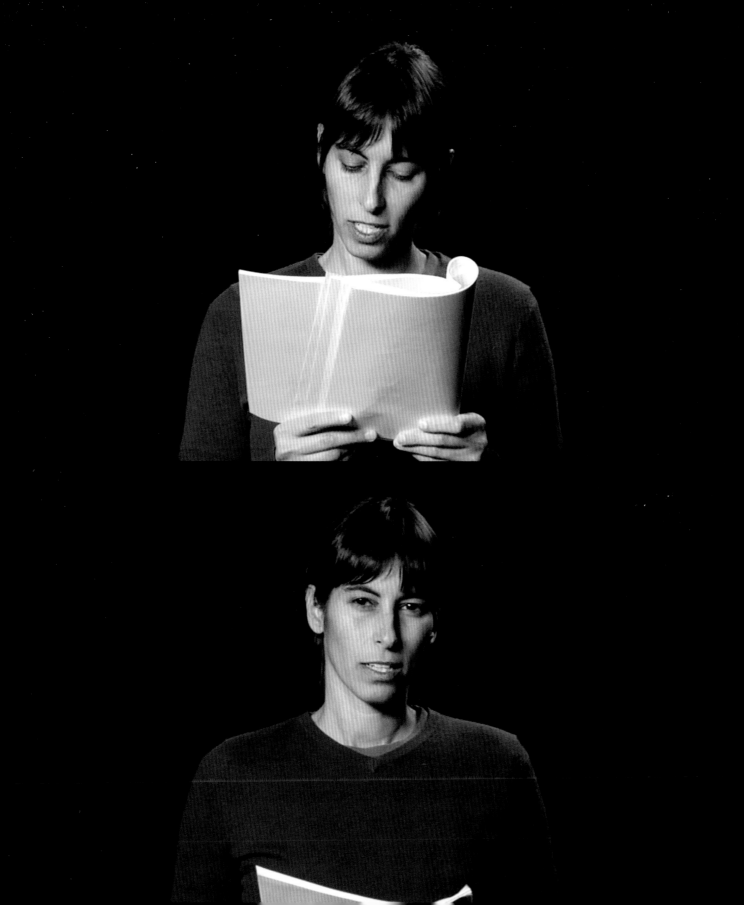

David Buckland

Ice Texts

The projections happen at the crossover of light from night to day, a short window of time when the power of the video projector matches the light of dawn, when there is both message and ice. It is so short and already the captain of the *Noorderlicht* manoeuvred his vessel to within eight metres of an iceberg as it towers above us. It could flip at any time.

As the message traverses the ice I soon realised that there is more than one kind of ice. At times the message is swallowed up, lost and then becomes visible again as the ice reflects, not absorbs. These icebergs from the East Coast of Greenland could be tens of thousands of years old, formed before the last ice age and are now breaking from the Greenland ice mass at alarming speed. The projections are slogans to make us reflect on our consuming appetite and lifestyle. To slow us down to consider the implications of a darkness even darker, of over-consumption, of banking models born on risk, greed and loss. Does it have to be thus? Do we need more only to lose more? Are we really willing to tempt the power of nature? Making these images is a risky business and the fleeting moment of opportunity is quickly lost. In ice time, our fleeting time of excess is so short; two hundred years of our time but for the glacier barely a single breath taken, then given and the consequences: the total loss of arctic sea ice. It is unimaginable that our children's children will only know these beautiful ice places from photographs; some, like these, carrying messages not heeded.

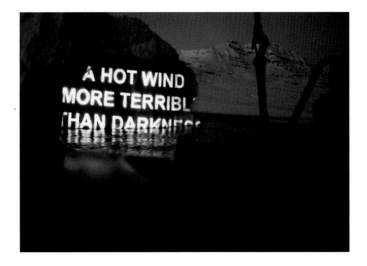

A Hot Wind More Terrible Than Darkness
Photographic print, perspex mounted
70 × 1100 cm
2008

Discounting the Future
Photographic print, perspex mounted
70 × 1100 cm
2008
Text by Amy Balkin

Portraits

Global societies are now connected more than ever before and our cultural icons achieve a status fed by media and press, where their fame goes before them, crossing borders and air space. On the Cape Farewell expedition to West Greenland, 2008, there were two impromptu music performances in small bars in Uummannaq and Ilulissat, deep within the Arctic Circle, where the words and music of KT Tunstall, Leslie Feist and Jarvis Cocker were already known by the locals who were happily singing along.

I made a series of portraits including some of these well-known performers and juxtaposed their image with a text taken from my conversations with them during and after the trip. They are an attempt to offer something beyond the photograph, an insight into how they experienced the expedition and formulated their own idiosyncratic expression of climate change.

Laurie Anderson

Musician
Cape Farewell expedition 2008

I spent a few weeks on a Cree reservation and one day some anthropologists arrived and they asked the oldest man on the reservation to sing some songs. And he started to sing but he just kept starting over and sweating and soon it was obvious that he didn't know any of the words. He just kept starting over and over, rocking backwards and forwards, sweating, and the only words he seemed really sure about were *heh ah i, heh i, heh ah, heh i.*

heh i, heh, heh i, heh i,
I am singing the song
heh i, heh, heh i, heh ah,
the old songs
heh i, heh i,
but I can't remember the words
heh i, heh i, heh,
I am singing these songs
heh i, heh i,
of my fathers
heh i, heh i, heh,
and of the animals they hunt
heh i, heh i, heh,
I never knew these songs
heh i, heh, heh i, heh ah,
I never went hunting
heh i, heh i,
I remember my grandfather
heh i, heh i,
he lay
heh i, heh i,
on his back while he was dying
heh i, heh i, heh,
I think
heh i, heh i,
I am
heh i, heh i,
no one.

Portraits. Laurie Anderson
Photographic print, aluminium mounted
66 × 90 cm
2010

Ryuichi Sakamoto

Musician
Cape Farewell expedition 2008

I believe this must be exactly how our ancestors felt: that they must have felt they were very weak and small compared to nature — the power of nature or the size of nature. Not only in the Arctic but in Africa, Asia, everywhere. The power animals have compared to us: we don't have sharp teeth or sharp nails, we don't run so fast, instead we have a language and group activity, communication skills. I'm not sure its good or bad because the same skills we have are harming nature and changing the climate so, somehow we have to maintain both our skills and nature.

Portraits. Ryuichi Sakamoto
Photographic print, aluminium mounted
60 × 90 cm
2010

Jarvis Cocker

Musician
Cape Farewell expedition 2008

I started playing the music whilst I was on the boat, and then the title 'Slush' was what I kind of imagined the North Pole would look like when we got there. Maybe it will have turned to slush like that horrible way snow turns in a city when it's been there for like a couple of days and it goes all brown and horrible. I like songs to be about personal things. I do think that you should base what you create on things that you've actually experienced and so it was important for me to go on the expedition so at least I had, not that I would pretend to understand the whole climate issue and what was going on, but I got to have a bit of an inkling of what it is all about. My point was well if things get really bad and all human kind dies out I wouldn't have anything to write about. So, it's kind of a selfish thing really, to hopefully keep the human race alive in some form.

The nearest the song has got to a chorus is the line where it says *my heart melted as your touch turned into slush*. Towards the end of the trip we were going down this fjord and I had one of those moments when I was on deck on my own and was kind of trying to in some way fix it in your mind or whatever and, I did get a bit emotional, I had a bit of a tear in my eye. Not like thinking *my God, the world is melting* more that it looked really beautiful and in a way that made me think, if for no other reason, you wouldn't want it to disappear because it's something beyond your understanding. And it's there and it's inscrutable. There's something very beautiful about the Arctic and it's been doing its thing for millions of years and it shouldn't stop because of something that we did, and I had that tearful moment at the beauty of it all. I guess that is where that line is from.

Portraits. Jarvis Cocker
Photographic print, aluminium mounted
60 × 90 cm
2010

Adriane Colburn

Forest for the Trees

Forest for the Trees is inspired by a swathe of the Peruvian Amazon that is the subject of a contentious debate over whether or not to allow oil exploration in the region. This area, along the Madre de Dios River and spanning parts of the Amarakaeri Communal Reserve and the Manu and Bahuaja Sonene National Parks is one of the most bio-diverse places on the planet. Oil exploration is anticipated to have a dramatic impact on the entire eco-system of the area and on the numerous indigenous people who inhabit the preserve.

This work investigates the role that mapping plays along the edges of highly populated, cultivated and commodified land. As we gain a deeper understanding of our planet and its natural properties, we are able to visualise the world in more precise and complex ways. Mapping technologies such as lidar, satellite and seismic imaging allow us to penetrate deeper into previously unknown layers of our planet. In doing this we make maps, and as we map, we gain authority that enables the exploitation of nature to suit human desire. In effect, if we can map it, we can lay claim to it.

Over the past several years, Adriane Colburn has developed a series of installations that seek to highlight changes in the infrastructure and networks of natural and urban landscapes. These constructions, comprising layers of hand-cut paper, metal, photographs and projected light, focus on unseen systems that exist below ground or are shielded by scale or the passage of time. To create these works, she goes through a process of elimination, editing out all visual information on the subject except a minute selection that becomes illuminated. She does this through physical removal, cutting out everything except imperative lines, thus creating images and abstractions that are informed by voids as much as by positive marks.

Forest for the Trees
Paper, ink jet prints, aluminium,
steel, ink, paint
305 × 305 cm
2010

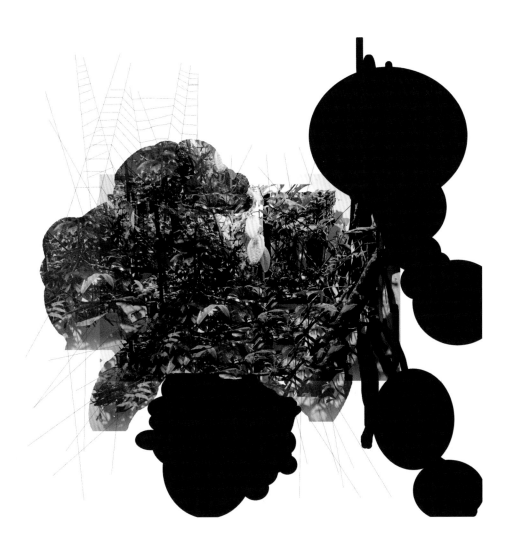

Forest for the Trees
Paper, ink jet prints, aluminium,
steel, ink, paint
305 × 305 cm
2010

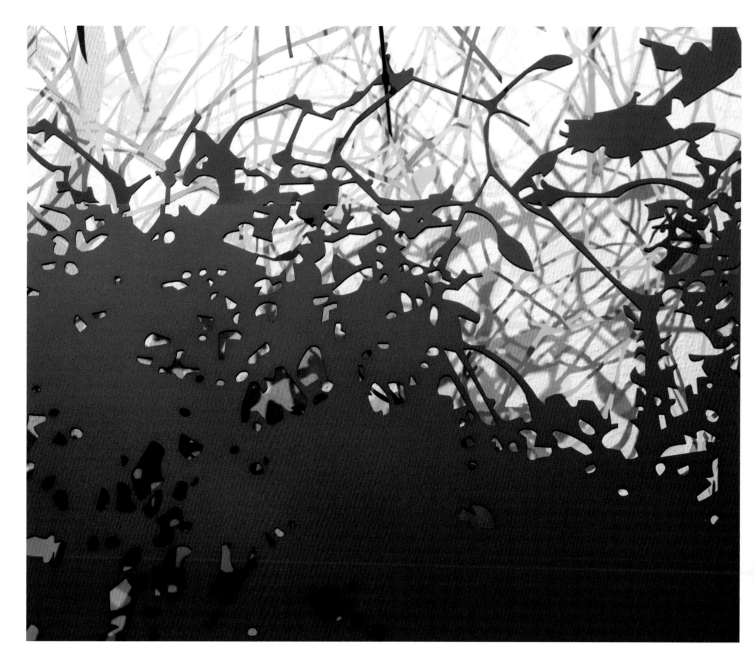

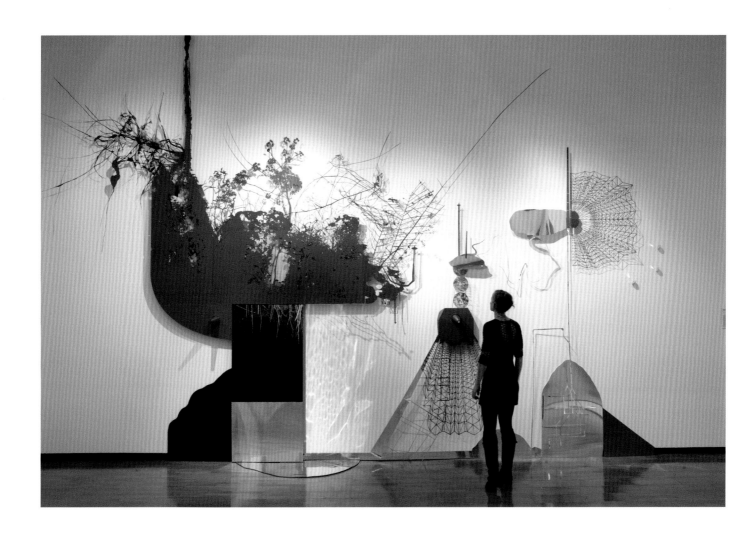

Forest for the Trees
Paper, ink jet prints, aluminium,
steel, ink, paint
305 × 305 cm
2010

47 Adriane Colburn

<u>Sam Collins</u>

Sometimes the Journey is Better than the Destination

One of the ways of dealing with the climatic issues that face us today is by expanding our thoughts to encompass what is outside the immediacy of our own experience. We are asked to consider where something has come from, what its journey has been, the impact it has had along the way, and what will happen to it once it continues on its way, how our actions will affect it and how it will affect others. We are required to think of a past and a future, beyond our own experience, and the selfishness of our own time and space.

The crates that contain the exhibition can be seen, in a simple way, as its packaging, but more interestingly, they can be seen as a representation of its longer timeline, a remnant of its history and a clue to its future – a physical reminder that this exhibition has a journey beyond whatever gallery it is experienced in. It came from somewhere and it will move on to somewhere else, it travels, it takes up space, it requires energy, materials and logistics. It existed prior to this exhibition and it will move on once it closes.

The crates are not just designed to be eco-friendly, energy efficient or bio-degradable: they are designed to be honest. To show what they are, where they come from and the impact they have, a reminder of the larger context, the bigger picture, the greater journey.

SOMETIMES THE JOURNEY IS BETTER
THAN THE DESTINATION

Sometimes the Journey is Better
than the Destination
Packing crates, GPS tracker,
cables, monitor
Dimensions variable
2010

Nick Edwards

Expedition to the Source of the Dollis Brook in search of the consequences of the ideas of the Sublime and the Beautiful

The conventional understanding of the sublime is one that has been framed by the world-view of the 18th century and as such must be open to critical reassessment.

The primary goal of the expedition is to re-survey the principal feature of the territory: the sublime, and ascertain if it is in fact the pinnacle that has long been believed. Or is it, like the beautiful, a foothill to a greater range that is yet to be discovered?

As the notion of travel for travel's sake is becoming a difficult activity to justify, the mode of travel will be endotic, an exercise in staying close by, not leaving the familiar and travelling interstitially through a world we thought we knew.

An example is Xavier de Maistre's *Voyage autour de ma chambre* (1794). In this account de Maistre treats his bedroom in Paris as if it were a vast, uncharted and perilous territory where moving from his bed to a chair has all the adventure of an expedition on the high seas.

Expedition to the Source of the Dollis Brook in search of the consequences of the ideas of the Sublime and the Beautiful
Inkjet print on paper
57 × 45 cm
2009

The Map of the Expedition to the
Source of the Dollis Brook
in search of the consequences of the ideas
of the
Sublime and the Beautiful

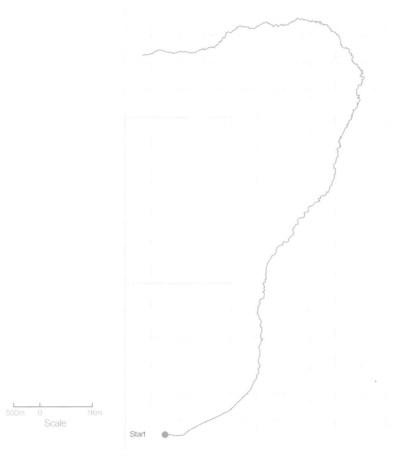

N

Start

500m 0 1Km
Scale

Instructions.

1. Print map onto A4 paper.
2. Acquire a 1:50,000 scale map of the area you wish to explore.
3. Place the Start on your point of departure.
4. Endeavor to follow the course of the Dollis Brook as closely
 and as safely as possible until you reach the end of the line
 you have discovered the source of the Dollis Brook.

<u>Leslie Feist</u>

Grey, Green, Blue, Black, White, Pink

I thought I'd film some Super 8, and give myself a frame to look at the enormousness through. The whirring sound of the camera made everyone nostalgic for that time when our memories were turned silent by film. It suited the north, turning the groaning and cracking to grainy quiet. These are some stills.

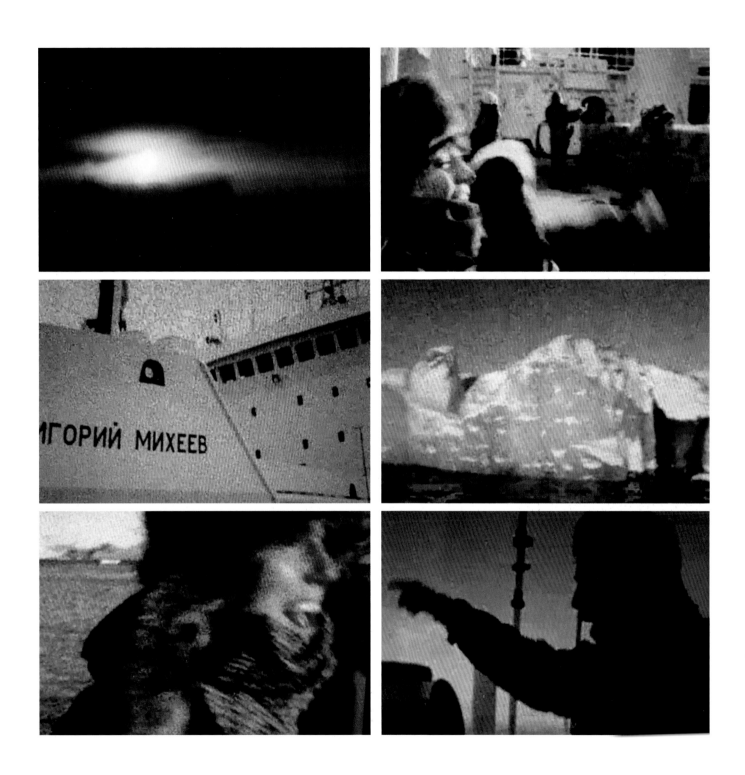

Grey, Green, Blue, Black, White, Pink
Super 8 mm film
2008

Francesca Galeazzi

Justifying Bad Behaviour

In the morning of 29 September 2008 I walked across fresh snow with a gas cylinder in my arms, containing six kilogrammes of CO_2. I took it across the unspoiled snow field of the Jakobshavn fjord, home to one of Greenland's largest and most active glaciers, which is losing twenty million tons of ice every day.

I carried it until I found a wonderful place, overlooking a strip of dark frozen water in which majestic white icebergs were silently drifting out to the open sea. The sky was a merge of pale grey and cerulean blue with a yellow glow just behind the skyline, making the icebergs stand out in their spectacular ephemerality. I thought to myself: this is perfect!

I walked to the top of a small hill, I laid the cylinder down, got on my knees and opened the valve. The CO_2 came out violently, freezing the air around the nozzle and producing an unpleasant whistle … *ppppsssssssssssssiiiiiiiiiissssssss* …

When I lowered the cylinder towards the ground, the snow blew off under the jet pressure, as if to signify the melting of the Arctic ice cap because of carbon emissions generated elsewhere.

When the cylinder was finally empty and I had discharged its entire CO_2 content, I reflected on my premeditated irresponsible act. It was actually not a harmful intervention at all. You see, I had previously offset the carbon emissions generated by this CO_2 release through an online Gold Standard Carbon Offsetting scheme. This made my action carbon neutral!

This is great stuff … one can go about consciously polluting the world, wasting energy, producing tonnes of waste and abusing natural resources without feeling guilty at all! One can simply pay someone to compensate for his or her 'bad' actions somewhere else, and become carbon neutral! Don't you think this is just great? Do you? Personally, I think this is not good enough.

A lot has to be done before we can revert to carbon offsetting as an effective mechanism to reduce global carbon emissions. Fundamental changes in societal behaviour are necessary to reduce our environmental impact, encompassing the way we live, travel, eat, consume, go on holiday and warm our homes.

Only after we have significantly reduced our environmental impact to the minimum possible, only then can carbon offsetting begin to be used efficiently. The cost of carbon is still too low to drive change.

Change must come from within.

Justifying Bad Behaviour. Performance
Photo by Nathan Gallagher

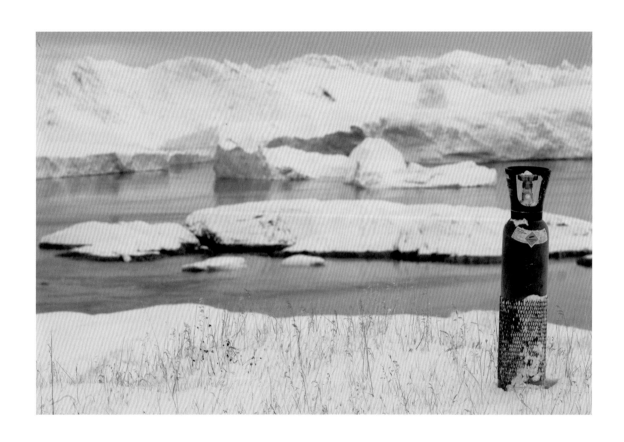

Justifying Bad Behaviour. Performance
Digital print on perspex
50 × 78 cm
2008
Photo by Nathan Gallagher

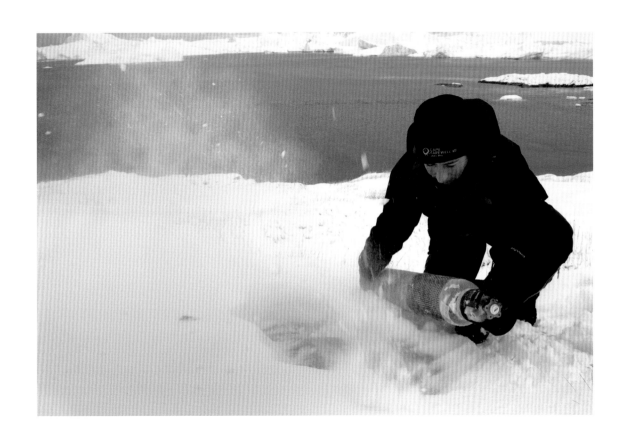

Justifying Bad Behaviour. Performance
Digital print on perspex
50 × 78 cm
2008
Photo by Nathan Gallagher

Francesca Galeazzi

Nathan Gallagher

Lateral Moraine meets Fjord

The complex issues of global warming are beyond the understanding of many of us. We are informed by others how to act in order to halt the ever failing conditions, and we do, some of us, act.

Then what?

We can't see how everyone else in the world acts so we don't know if we are part of a wave or standing alone against a tide. This can be a rather depressing thought.

So when you look at these photos, try and see something special, something amazing, something worth trying to save – it helps.

Obviously not all the photos I took on the voyage serve this purpose. My role as the resident photographer was as much to document what was going on around us as it was to document what was going on amongst us. I found both roles were equally fascinating.

Lateral Moraine meets Fjord
Archival C-type print on paper,
mounted on aluminium
1203 × 1711 cm
2008

Marije de Haas

Wellness over time

During the 2009 Cape Farewell trip to the Peruvian Andes and Amazon, Marije tracked the crew's physical reaction to the various climate extremes they were put through: altitude, humidity, cold, heat, diet, exertion and wildlife. The results are logged on this chart showing the intensity of the crew's experiences.

Wellness over time
Inkjet print on paper
55 × 92 cm
2010

Robyn Hitchcock + KT Tunstall

There Goes The Ice

On the Disko Bay voyage, 2008, Robyn Hitchcock wrote the song 'There Goes The Ice' after Chris Wainwright asked him to spell out 'Here Comes The Sun' with semaphore lights on the deck of the ship. Robyn took the song fresh to KT Tunstall in the next-door cabin and they recorded it there and then.

There Goes The Ice

There goes the ice
Falling
Into the sea
Calling me home

Forgotten land
Crumbling
Into my hand
Tumbling down stairs

Is it any wonder you can't
Live with yourself
Anymore?
Is it any wonder you can't
Live with yourself
Any more?

'There Goes The Ice'
Recording
DVD, 3 min
2010

There Goes The Ice
Handwritten lyrics
2010

There goes the world
Turning
All round itself
Burning ice
Alive...alive

There goes the ice
Breaking
Into the sea
Taking me
Down

Is it any wonder you cant
Live with yourself
Anymore?
Is it any wonder you cant
Live with yourself

Anymore
There goes the ice
There goes the ice
There goes the ice
There goes the ice

Performed by Robyn Hitchcock and
KT Tunstall

Recorded by Luke Bullen

Words & music by R. Hitchcock
published by August 23rd / BUG music

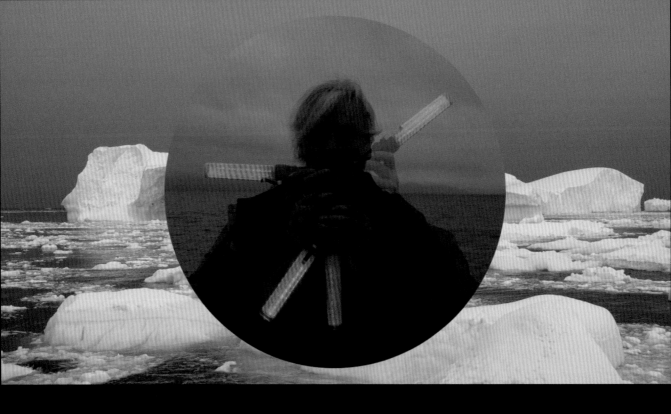

There Goes The Ice
Video loop
2010
Lyrics Robin Hitchcock
Performed by Robin Hichcock + KT Tunstall
Images by Chris Wainwright

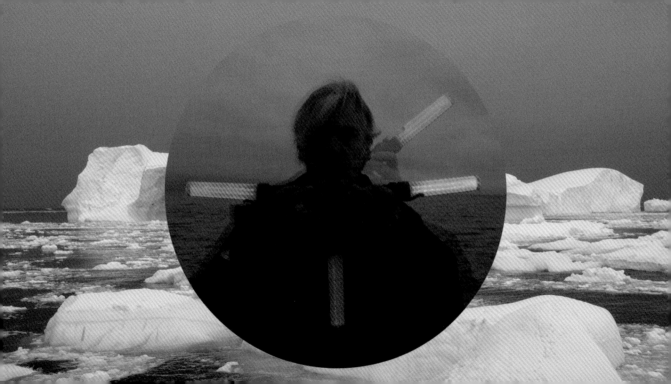

Ian McEwan

The Hot Breath of our Civilisation

The pressure of our numbers, the abundance of our inventions, the blind forces of our desires and needs are generating a heat – the hot breath of our civilisation. How can we begin to restrain ourselves? We resemble successful lichen, a ravaging bloom of algae, a mould enveloping a fruit.

We are fouling our nest, and we know we must act decisively, against our immediate inclinations. But can we agree among ourselves?

We are a clever but quarrelsome species – in our public debates we can sound like a rookery in full throat. We are superstitious, hierarchical and self-interested, just when the moment requires us to be rational, even-handed and altruistic.

We are shaped by our history and biology to frame our plans within the short term, within the scale of a single lifetime. Now we are asked to address the well-being of unborn individuals we will never meet and who, contrary to the usual terms of human interaction, will not be returning the favour.

Pessimism is intellectually delicious, even thrilling, but the matter before us is too serious for mere self-pleasuring.

On our side we have our rationality, which finds it highest expression and for-malisation in good science. And we have a talent for working together – when it suits us.

Are we at the beginning of an unprecedented era of international co-operation, or are we living in an Edwardian summer of reckless denial? Is this the beginning, or the beginning of the end?

The Hot Breath of our Civilisation
LED display
260 × 20 × 10 cm
2006
Photo by Francis Ware at GSK Contem-
porary / Royal Academy of Arts, London
Earth: Art of a Changing World

Brenndan McGuire

The River

The River image was made with a cheap point-and-shoot camera and embellished with a soundtrack containing some ambient, original music and sounds that I recorded in the jungle. I tried to capture the feeling and nostalgia that I have for the journey down the river.

Movement

The audio work *Movement* is a soundfield of recordings that I arranged specifically to add a backdrop to the Unfold exhibition.

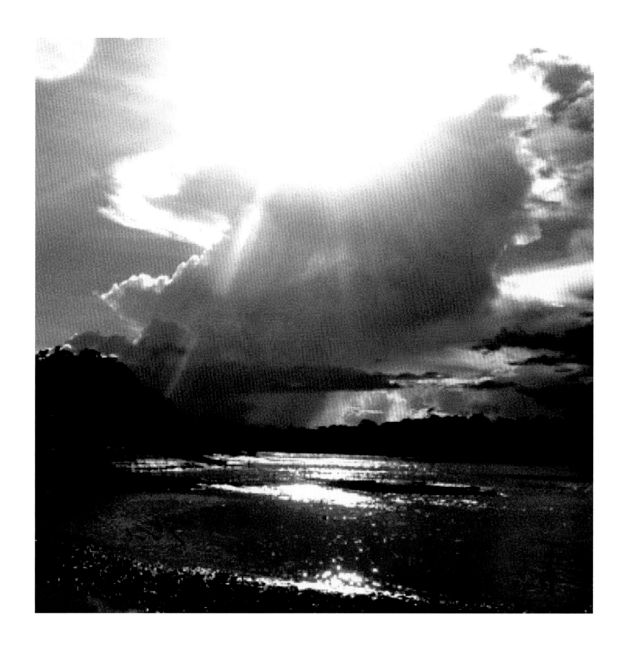

The River
Video
8 min
2010

Brenndan McGuire

Daro Montag

Leafcutter ants
Leafcutter ants – an organism in motion
Harvesting food supplies from a distant location
Following ingrained patterns of behaviour.

An oily line of carbon disrupts their path.
What happens when they encounter this totally unexpected intrusion into their world?
What choices do they have?
What decisions do they make?
Can they learn from experience and adapt to the new circumstances?
Can they incorporate this knowledge into their worldview?

In what way is our behaviour reflected in that of the ants?
In what way does their behaviour mirror ours?

What responses will we make as carbon completely changes our world?

Leafcutter ants – an organism in motion
Harvesting food supplies from a distant location
Following ingrained patterns of behaviour.

An oily line of carbon disrupts their path.
What happens when they encounter this totally unexpected intrusion into their world?
What choices do they have?
What decisions do they make?
Can they learn from experience and adapt to the new circumstances?
Can they incorporate this knowledge into their worldview?

In what way is our behaviour reflected in that of the ants?
In what way does their behaviour mirror ours?

What responses will we make as carbon completely changes our world?

Daro Montag & Leafcutter ants
Digital video by Matt Wainwright
3 min 53 sec
2009

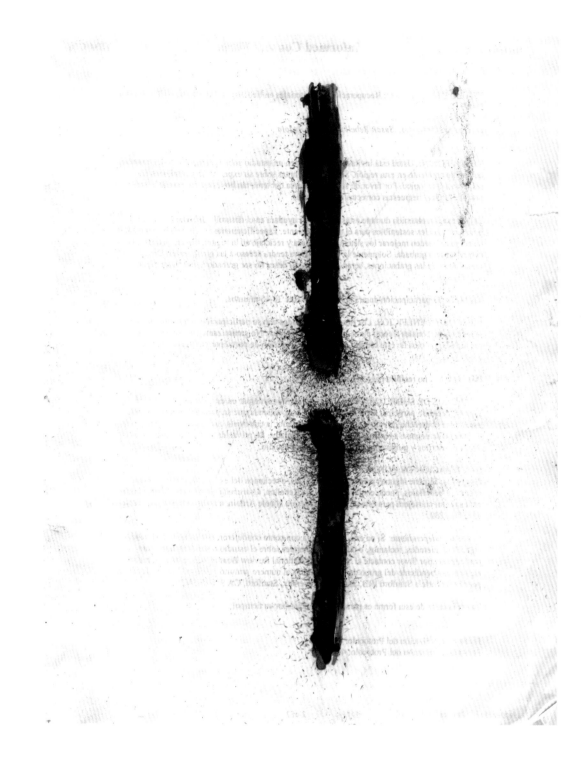

Leafcutter ant drawing, Amazon rainforest
Carbon and oil on pre-used paper
28 × 22 cm
2009

RANE-CHAR

RANE-CHAR is an art project that uses biochar to promote positive action to help combat climate change. Biochar is a fine-grained, highly porous charcoal that helps soils retain nutrients and water. It is found in soils around the world as a result of vegetation fires and historic soil management practices. In Pre-Columbian times soil over a large area of the Amazon rainforest was regularly treated with biochar by the indigenous people. Through this action the poor, yellow, Amazonian soils were transformed into the rich, dark earth known as Terra Preta. This practice enabled a more sustainable way of life as the land could be farmed and support a large population. Intensive studies of Terra Preta have led to a wider appreciation of the unique properties of biochar in helping to maintain a healthy soil.

In addition to its properties as a soil conditioner, biochar also has significant potential as a means of reducing greenhouse gases. During their lifetime plants take carbon dioxide out of the atmosphere and store the carbon in their material. When wood and other organic materials are turned into charcoal, through the process of pyrolysis, much of that carbon is turned into a form that resists degradation for hundreds, even thousands, of years. By using it as a soil conditioner biochar effectively sequesters the carbon and acts as a sink that overall is carbon negative. It can therefore contribute to the fight against climate change.

Members of the public are invited to participate in the *RANE-CHAR* project by ordering a bag through the RANE website, burying its contents at a location near their home address, and completing and returning the attached label. This action will be added to the global map of *RANE-CHAR* sites. The bag can be retained as an artist's multiple or, alternatively, it can be composted.

Bags can be obtained from www.rane-research.org

Charcoal after pyrolysis

RANE-CHAR
Crate with twelve 1 kg bags of biochar
79 × 46 × 46 cm
2010

Michèle Noach

The Future Myth of Ice

Like everyone else, I presume, I feel an attraction for zero points, for the axes and points of reference from which the positions and distances of any object in the universe can be determined.—Georges Perec from *Species of Spaces* (1974)

Into the glaciosphere. Leaving the reddening urban tangle behind and sailing North, glorious North and into the lethal, crystalline white. The vast toothpaste palaces laced with television-blue hieroglyphs, towering above us, threatening and innocent, in the way of all utter beauty.

Twice I have clambered aboard Cape Farewell vessels and headed into the High Arctic: once in 2004 on the *Noorderlicht*, a century-old Dutch schooner upon which we circumnavigated Svalbard (the archipelago halfway between the top of Norway and the North Pole), and again in 2008 on the Finnish research vessel *Grigory Mikheev*, which took us up north along the West Greenland coast. Twice, heading towards the brass clasp of the toy globe, we dodged icebergs the size of colleges, leaking bleach-blue ink, crackling like kisses. Twice I sank into the Northern reverie that renders you dumb, floundering for adjectives or expletives, when silence is better.

Caveat sailor. Sailing into the ice makes you not want to come back. The daring simplicity of the Arctic challenges you to think any other way of life has meaning, it mocks your ambitions and desires and lays its sublime cards on the ice, trumping any hand you hold. Its oblivion burns too delicious to deny. Its crazy, mindless beauty, its indifference and fragility all conspire to set the spell.

The scientists always got to work right away: they had their measuring devices and were envied by us artists because they could so accurately record their findings. They got busy defining their discoveries with the minutiae of diligent practice. They had solid, irrefutable data, numbers, graphs, volumes. The artists had a sense of the place, but what the hell is that? How to nail this thing? Paralysed with the panic of not knowing what to do, we needn't have worried. Porous sponges, we could not help but absorb great vats of strangeness that the Arctic offered up and like a deck full of alarm clocks, we started ringing one after the other, as ideas and irresistible inspiration set us off.

Scrambling up a very Northern ice-cap, around the 80th parallel, was a literal turning point. Having separated from the others, I climbed to the top of the ice where the sky, sea, air and ground were all the same non-colour. I was nowhere, but stood at the top of the world, like James Cagney, ready to explode with the reality of it. Not right at the top, not at 90°, but because the ice-sheet was curved and there was no one else visible, looking down, all the world was revolving to the South of me; all the frenetic, histrionic business of living our voracious lives, the hysteric consumer trolley-dash to the finish line, all lay below my feet. I had world vertigo.

And then on a freezing breeze came liberation and peacefulness. There was a very clear sense of where I was: one of the great cooling towers of Earth. A crucial regulator, a thermostat in the world's attic. Like an Ant & Bee drawing, or like the Clangers on their planet, I knew precisely and for the first time, *where* on Earth I was. The whole became apparent and simple. The gorgeousness of the place was clear, but an understanding of what this insane place *does* for a living was also revealing itself.

On that first trip I decided to steal the authoritative templates of science to make pseudo-scientific graphs and charts called *The Arctic Feel-O-Graphs*. These measured how the Arctic *felt*: the one thing that the scientists could not measure. I used

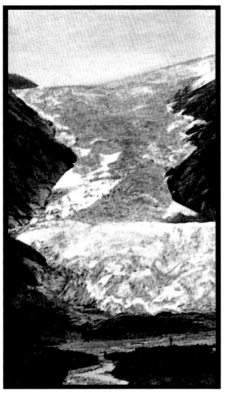

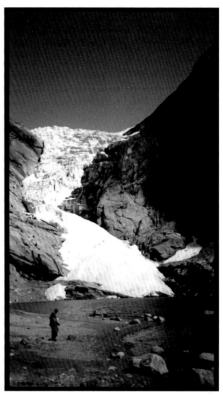

Through The Ice, Darkly:
Brixdalsbræ
Lenticular print
37 × 22 cm
2010

Through The Ice, Darkly:
Brixdalsbreen
Lenticular print
37 × 22 cm
2010

lenticulars as a medium because they replicate ice so well: an illusory three-dimensional medium that captures the translucency of ice, its ability to manipulate light and colour. Lenticulars hint at the information contained, emulating ice (a natural two-way mirror, a classic heterotopic space) with its hundreds of thousands of years of data encapsulated in the frozen bubbles of air deep within it, lost to the atmosphere as it melts away. And as the viewer moves, so does the image, making you doubt what you've seen. Your viewpoint affects your viewpoint, so to speak.

After the second expedition, glaciers and their architecture became increasingly puzzling and tantalising to me, and during the summer of 2009 I travelled to five further Norwegian glaciers (Brixdals-, Kjenndals-, Suphelle-, Bøya- and Bondhusbreen) to archive their retreat. I had been collecting Norwegian postcards, circa 1890–1930, of these specific glaciers. The postcards (dated and geographically located) represent an accurate, and more interestingly, unintentional record of the position and condition of glaciers a century ago, mostly captured in a desire to communicate the romanticism of the area, for tourists, travellers and those abroad who could not reach these places. There are also mysterious

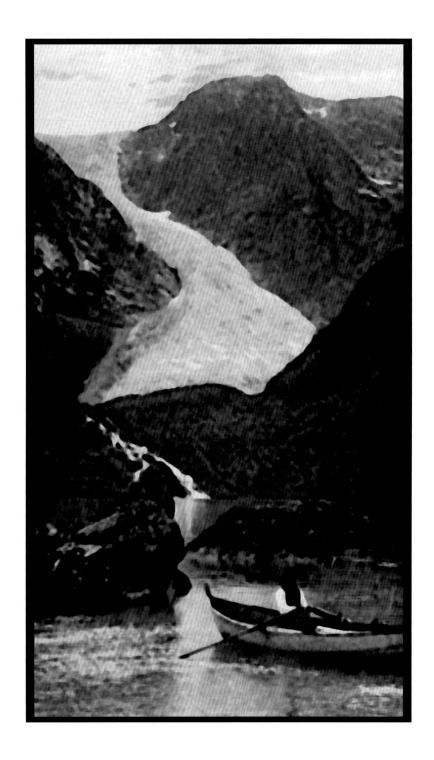

Through The Ice, Darkly:
Bondhusbræ
Lenticular print
37 × 22 cm
2010

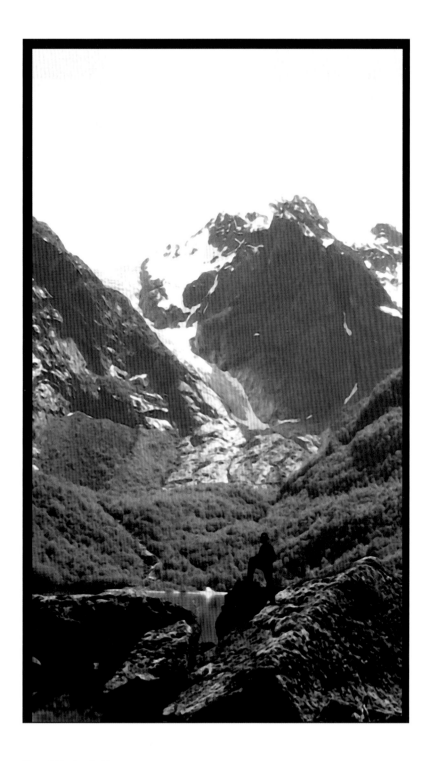

Through The Ice, Darkly:
Bondhusbreen
Lenticular print
37 × 22 cm
2010

figures in the postcards, Norwegian tourists of that era, standing proudly or fearfully beside these regal frozen tongues that slid down dark mountains to greet them. The compositions seem to hint at nostalgia for a lost ice world before we even knew we were losing it. The anonymous photographers cannot have known they were creating brilliant semi-scientific data that would be of such interest to geographers, scientists, climatologists and artists of the future.

Scoping the faces of the Victorian tourists as they edge their way in front of the creaking glaciers of the theatrically gesturing coast, one searches for some sign that these travellers knew something of what they had started, sensed that they were part of a world culture that was unstoppable, a machine of infinite momentum and appetite. Were they the last of the breed or the first? And could they have wondered already then if that hunger for growth, material wealth, comfort, that wildly, dizzying success of being Modern, would have written in its very DNA its undoing. Or at least, that the racing car of progress had its brakes hardwired to stop, perhaps screechingly, two hundred years hence. Had they factored in the Promethean fault-line, the finger wagging of Icarus?

The Industrial Revolution, now well underway, was watching over the first population to assume machinery as part of life, the generation that would be comfortable with dominance over nature on an industrial scale and be absolutely unencumbered by worries of concomitant pollution. And as costumes mutated in the foreground, the hinterland machinery cranked its grinding gears into growing ever more colossal, ubiquitous, irresistible. How vividly we see the dark satanic millinery that dressed the new mercantile rich on their increasingly exotic vacations abroad, whilst the bonded workforce oiled, fed and were eaten by the fabulous mechanical monoliths of the new commercial world. How wonderful – there was now nothing we couldn't do. And until the Titanic and WW1, the twin towers of our loss of innocence, all bets were on. No mote of doubt would arrest this thrilling explosion of industry. The future, including nature, the very world's fabric, was ours. No room for cynicism, Luddites be damned, *We Can All Have Everything*, read all about it. On your slate or your Kindle.

This handsome monochrome landscape, drawing admirers from afar to stand in awe of these sensuous iced tendrils adorning the fjordal mountains. The dark chasms lit by ice, brought to enchanted life by the semi-magical phenomena of The Glacier. Supracompacted ice forming a squeezing organic slo-mo river, a visceral rock, liquid giggling crystal of the mountain's distillery.

A century on and these glaciers have shrunk, admonished by the warmed air. Climate changes are complicated and maritime glaciers expand during warm periods sometimes, due to excessive winter rainfall combined with mild summers, so reading the runes is not straightforward. But in conversations with glaciologists in Norway it was clear, sadly, that the overall arc of data showed a general decline in all the glaciers, with some in very rapid retreat. All the ones I visited, from Svalbad to southern Norway, had shrunk dramatically, and despite a small flourish in the late 90s all gains have since been lost.

Through The Ice, Darkly is a series of 3D lenticular prints based on these travels to the glaciers as they stand now and their old depictions, presented in pairs. My real interest was in capturing the change of atmosphere, archiving how the landscape had altered and how that felt, and not a detailed *before and after* comparison of ice mass.

In this series, when representing the revisited glacier sites, I slipped in characters from the old postcards, and had them looking for the vanished ice. Who had taken their glacier? They crossed a century to wander an eerily dark rockscape, as I had, in search of the once terrifying glaciated fronts of ice and moraine, which had in most cases diminished to a trickle of melt water.

Sea-level rise (from melting ice-sheets), drought, flood, hurricanes, populations on the move, crop failure, creeping disease, rising sea temperature (thus more flooding as the seas expand) and the exponential effects of positive feedback (for example permafrost methane release): all this evidentially increasing in frequency around the world, highly visibly and the reduction of the glaciers is just one more teacup to fall off the table.

Is the world ready for what lies beneath the ice? Are we prepared for an unglaciated Norwegian coastline that is bare, dark rock? Is an ice-free Arctic imaginable? How will we describe what ice was like without sounding fanciful? Ice is on course to acquiring mythical status, something that belonged to another age and is hard to imagine, a notional and phantasmic nostalgia.

What did you do when the ice melted? Absolutely nothing. We stood in static horror at what we'd done – this breathless hubris that resolved into a climate's revolt and we left the children to clear it up.

Was there really ice? What was it like? Was it really that cold and white? Was it soft like plasticine? What did it taste of? How loud was it when those office blocks of ice collapsed? Was it really like the gods roaring?

Narnia, Ultima Thule and the Snow Queen's realm, these mythic, enchanted worlds we invent and desire: they are real, we have them right here on our doorstep. Magic but ours. And still we insist on turning the production of our luxuries up to 11. Will children in decades to come really believe that ice formed a metamorphic skin on these black rocks? That glaciers hundreds of metres thick squeezed their imperious way down through the future rubble landscape, transforming mountains and creating domains of ice laden valleys. How fantastical might it sound? Cold and clear and cackling and a thousand hues of white, powerful as gravity, delicate as web. Old folks dreaming.

Michael Collins of the Apollo 11 space mission said Earth was a fragile gem he'd never considered before he saw it from space. A cyan-emerald gemstone suspended vulnerably in the liquid blackness; he said his primary instinct was to protect it. Why do we always have to go on holiday to get perspective? Why to the moon to see the Earth? We are magnificent. The very least we are capable of is housekeeping.

These souls wandering around the glaciers and again a hundred years later, the empty glacial valleys: they mid-wifed the CO_2 exhaling monster, the flatulent ogre of our comfort and wealth that had life breathed into it by our very competence, ingenuity, creativity. What on earth was wrought? To this day we can't bear the thought of being rent apart from this guarantee of infinite output, excellence, material wealth, property, profit and propulsive progress. Our attachment, so undentable, so *understandable*, is now our weakness – we are growth junkies.

Please, *please*, someone ration me.

Thank you to Stein Iversen and The Royal Norwegian Embassy in London for their support.

Lucy + Jorge Orta

Vitrines and *Windows on the World*

In the work of Lucy + Jorge Orta, *Vitrines* and *Windows on the World* are focal points drawing our attention to a specific subject or issue. We usually find a photographic reference and a series of metaphorical objects inside or suspended from the structures. In these two works, the artists' photographs from their expedition to the Peruvian Amazon are enlarged or fragmented; in the case of the antique Spanish window frame, whose doors and shutters open in an Alice in Wonderland voyage, revealing the different Amazon landscapes. The *Vitrine* makes reference to the artists' longstanding research focus on the subject of water, containing bottles from their water purification projects in Rotterdam and Venice, as well as the iconic pierced gourds and containers.

 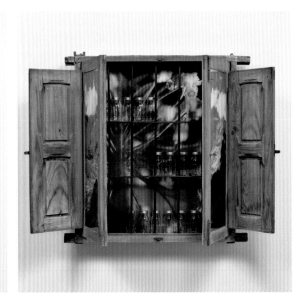

Windows on the World – Amazonia
Wooden window frame, Lambda
photographs Dubon laminated,
20 plasma bottles
90 × 100 × 25 cm
2010

Courtesy Galleria Continua,
San Gimignano / Beijing / Le Moulin
Photos by Ela Bialkowska

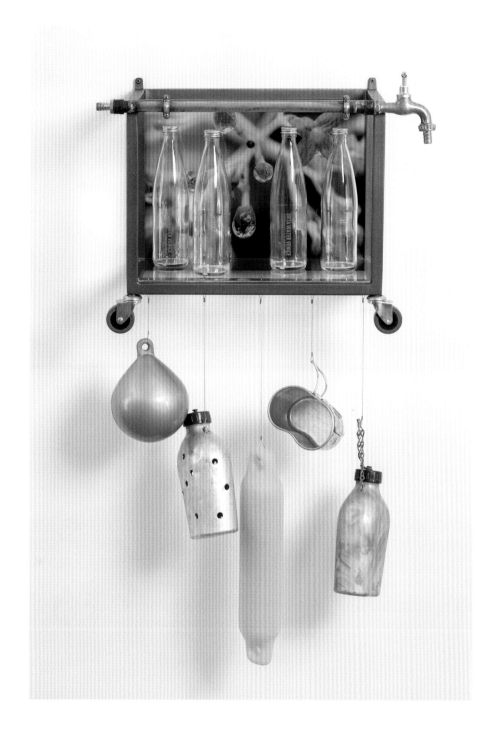

Vitrine – Amazonia
Steel structure, copper tube, tap,
laminated Lambda photograph,
4 OrtaWater bottles, 2 floats, 2 flasks,
aluminium cup
45 × 89 × 24 cm
2010

Collection of the artists
Photo by Bertrand Huet

Sunand Prasad

Greenhouse Gas

On a beach at the end of a fjord in Disko Bay, Greenland, now made accessible by
a retreating melting glacier, Sunand Prasad created the installation *Greenhouse Gas*
comprising four tethered helium balloons, delineating 540 m³ of space, representing
one ton of CO_2, the average emission per person per month in the UK.

This work can be repeated and re-interpreted as an installation in conjunction
with the venues on the Unfold tour.

Greenhouse Gas
Disko Bay, Greenland
2008
Photo by Nathan Gallagher
Equipment supplied by Creatmosphere

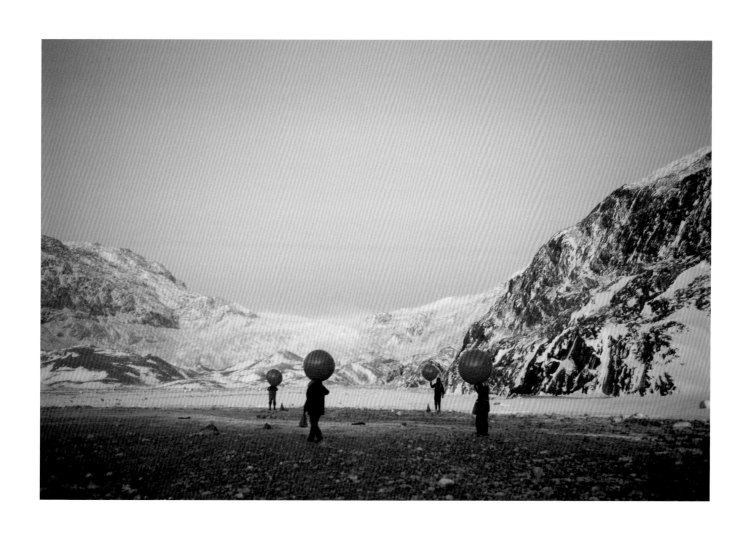

Greenhouse Gas
Disko Bay, Greenland
Photographic print on aluminium
56 × 84 cm
2008
Photo by Nathan Gallagher

83 Sunand Prasad

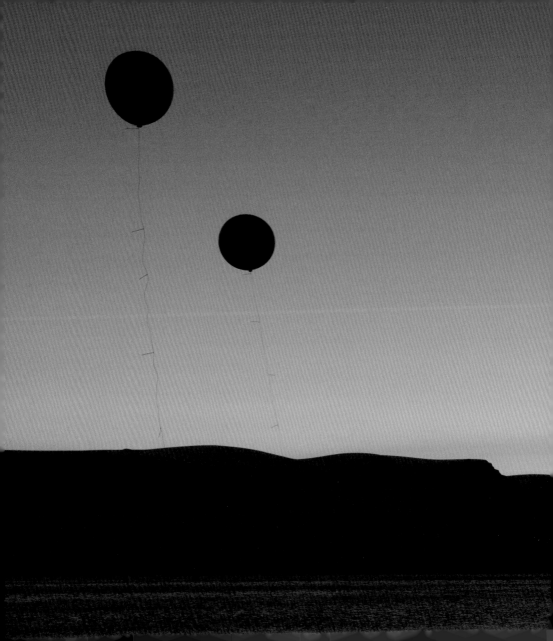

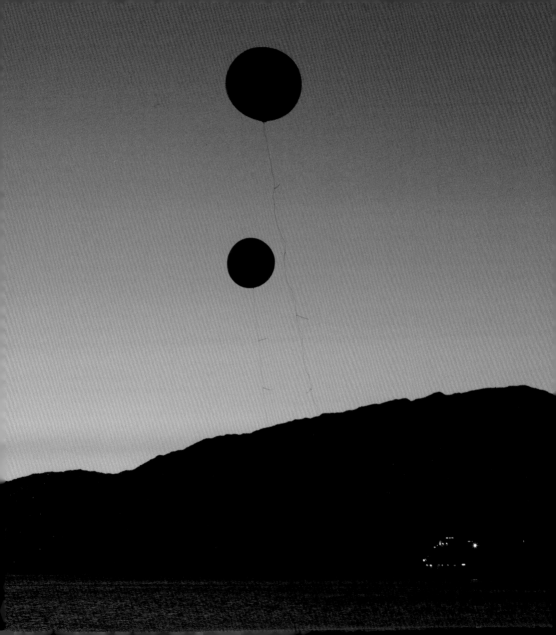

Tracey Rowledge

Arctic Drawing

I made three series of drawings aboard the *Grigory Mikheev* whilst on the Cape Farewell 2008 expedition to Disko Bay. They came out of the desire to make work that embodied an emotional response to climate change. The work evolved from an idea I took with me: to make drawings with felt-tip pens that would then be submerged in arctic water.

In the first series of drawings, the idea of *what* to draw only materialised when I was sitting in my cabin with a piece of paper on the floor and a pen in my hand. Using my arm as a pendulum, the movement of the sea created the marks. My body became the vehicle for translating and recording the sea's movements. I then submerged each drawing in seawater; the marks bled as the dye moved on the paper. These drawings became both of the sea and by the sea – incorporating the movement and the substance of the Arctic Ocean.

In the second and third series of drawings, I set up a pendulum underneath the chair in my cabin, with one or more felt-tip pens at the end of it, thereby removing myself as the translator. It was important to me that as well as dating the drawings, I recorded the start and finish time to give the ship's co-ordinates, so that each image relates to a specific date, time and place.

I was fascinated by the visual data collected by the scientific teams and saw my site-specific drawings as a direct, creative response to those as well as fulfilling my overwhelming need to make work that captured the moment in time.

Arctic Drawing: Series 1, no.2
28 September 2008
Cape Farewell, 2008 Disko
Bay Expedition
69°10.42'N 53°36.75'W
Black felt tip on paper
46 × 35 cm
Cape Farewell Collection
Photo by Prudence Cuming
Associates Ltd

Arctic Drawing: Series 1, no.5
28 September 2008
Cape Farewell, 2008 Disko
Bay Expedition
69°10.40'N 52°40.00'W
Black felt tip on paper
46 × 35 cm
Cape Farewell Collection
Photo by Prudence Cuming
Associates Ltd

Arctic Drawing: Series 1, no.11
4 October 2008
Cape Farewell, 2008 Disko Bay
Expedition
69°37.40'N 55°02.99'W
Black felt tip on paper
46 × 35 cm
Cape Farewell Collection
Photo by Prudence Cuming
Associates Ltd

Arctic Drawing: Series 2, no.4
30 September 2008
Cape Farewell, 2008 Disko
Bay Expedition
69°15.30'N 51°05.7'W
Colour felt tip on paper
46 × 35 cm
Photo by Prudence Cuming
Associates Ltd

Arctic Drawing: Series 2, no.6
1 October 2008
Cape Farewell, 2008 Disko
Day Expedition
70°46.28'N 54°38.9'W
Colour felt tip on paper
46 × 35 cm
Photo by Prudence Cuming
Associates Ltd

Lemn Sissay

What if?
I was commissioned by Southbank Centre to work with musicians, Gary Crosby OBE and Peter Edwards. Meanwhile Channel Four commissioned me to make a piece of work on the subject of Darwin for their TV slot *Three Minute Wonders*.

The two projects flew together perfectly. Having recently returned from a sojourn to the arctic with Cape Farewell the organic natural force of the piece began to take shape and since the matter was fresh in my mind, the subject of Darwin and climate change and the financial crisis converged and *What if?* was born.

And each time it is viewed it becomes itself once more. It happened naturally and with nature.

What if?
DVD, 3 min
2009

A film by Lemn Sissay
Musicians Gary Crosby and Peter Edwards
Camera: David Scott
Sound: Mick Ritchie
Artsadmin Producer: Gill Lloyd
Executive Producers: Judith Knight, Bob Lockyer
Series Producer: Deborah May
Title Design: Jennie Smith
Produced by: Artsadmin, DVDance for Channel 4
Supported by Wellcome Trust,
Calouste Gulbenkian Foundation, Southbank Centre
All films © Artsadmin and the artists
www.darwinoriginals.co.uk

Photo by Nathan Gallagher

LEMN SISSAY: WHAT IF?
A lost number in the equation.
A simple, understandable miscalculation.
And what if, on the basis of that,
the world as we know it changed its matter of fact?

Let me get it right
What if we got it wrong
What if we weakened ourselves getting strong
What if we found in the ground a vial of proof
What if the foundations missed a vital truth
What if the industrial dream sold us out from within
What if our impenetrable defence sealed us in
What if our wanting more was making less,
And what if all this wasn't progress?

Let me get it right.
What if we got it wrong
What if we weakened ourselves getting strong
What if our wanting more was making less
And what if all this wasn't progress
What if the disappearing rivers of Eritrea,
The rising tides and encroaching fear,
What if the tear inside the protective skin of earth
Was trying to tell us something

Let me get it right.
What if we got it wrong
What if we weakened ourselves getting strong
What if the message carried in the wind
Was saying something
From butterfly wings to the hurricane,
It's the small things that make great change,
And the question towards the end of the lease is
No longer the origin but the end of species.

Let me get it right.
What if we got it wrong
What if the message carried in the wind was saying something?

Shiro Takatani

Ice core
This installation presents photographs of part of a 2503 m ice core drilled at Dome Fuji in Antarctica.

The work was made with cooperation of Institute of Low Temperature Science, Hokkaido University, National Institute of Polar Research, Japan, Takeo Hondo, Atsushi Miyamoto, Gorow Wakahama, and Fujiko Nakaya.

Ice core (detail)
Media installation
2005

Ice core
Media installation
2005

Ice core
Media installation
2005

Clare Twomey

Specimen

Specimen is beautiful and yet intentionally uncomfortable. The unfired clay flowers are both natural and unnatural: their scale, weight, material and colour are unfamiliar, but their beguiling quality and fragility are recognisable. The flowers in the wooden box are protected from the environment; those on the integral tray are subject to the impact of change through their journey in this exhibition, highlighting the damaging effects of our curiosity. The flowers are protected yet displaying their loss through the constant change placed upon them by the rigours of the journey they must make. We have done our best to protect them, but it is not enough.

Specimen
Unfired china clay
60 × 40 × 28 cm
2009
Supported by Aynsley China Ltd

Specimen
Unfired china clay
60 × 40 × 28 cm
2009
Supported by Aynsley China Ltd

Chris Wainwright

Red Ice – White Ice

Red Ice – White Ice is a series of photographs made at night whilst circling around icebergs in a small inflatable rib off the north west coast of Greenland in sub-zero temperatures. I was acutely aware of the real possibility of these vast structures suddenly collapsing and capsizing our tiny vessel as I manoeuvred close enough to photograph them.

The images were made using either red or white flash to reflect the dangers associated with the climatic changes affecting the planet. This came into sharp focus as I observed and experienced first hand the potential threat to human existence in this vulnerable and fragile wilderness.

This work could not have been undertaken without the cooperation of the crew of the *Grigory Mikheev* and the assistance and calculated risk taken by Theresa Elwes, Zak Piper and Nathan Gallagher.

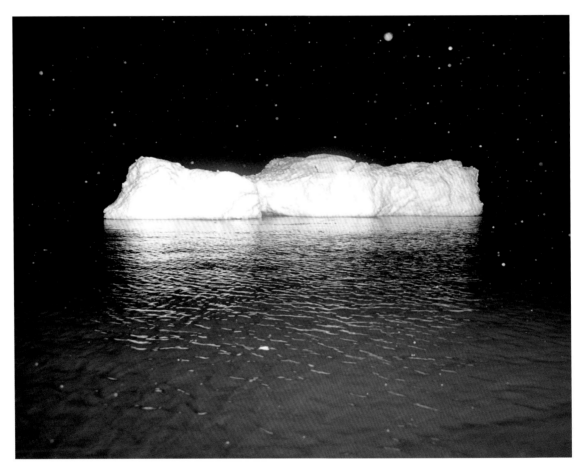

White Ice 1
Disko Bay, Greenland
C-type print on aluminium
1203 × 1711 cm
2009

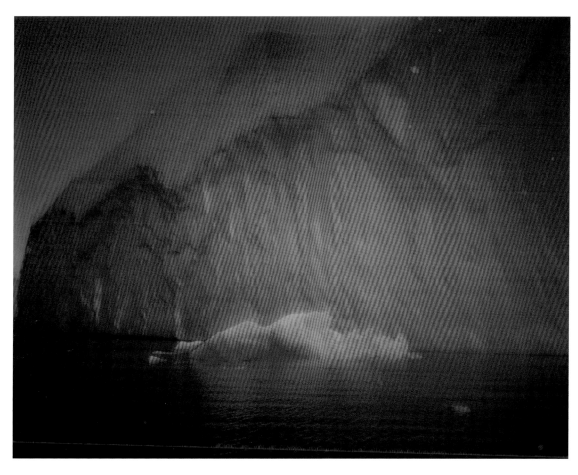

Red Ice 3
Disko Bay, Greenland
C-type print on aluminium
1203 × 1711 cm
2009

Chris Wainwright

Here Comes The Sun – There Goes The Ice

The origin of *Here Comes The Sun – There Goes The Ice* partly goes back to a Sunday evening in Hastings, UK at one of a number of street festivals that Hastings seems to have in abundance, many with pagan origins and nearly always involving music and alcohol. Walking down the High Street I came across a large flatbed truck on the back of which was a local band playing popular songs. As I passed, they started to play 'Here Comes The Sun' by the Beatles and both the title of the song and the line 'The ice is slowly melting' stuck in my mind as I struggled to prepare myself for the fast approaching arctic voyage on the 2008 Disko Bay expedition.

Subsequently sitting on board the *Grigory Mikheev* one evening somewhere off the west coast of Greenland, I turned to Robyn and asked if he could remember the lyrics to 'Here Comes The Sun'; he could. We wrote them out and I started to explain an idea to make a semaphore signal performance version of the lyrics as the sun was rising. Later, well, much later, in fact that night, we went on deck and I photographed Robyn signalling the title of the song 'Here Comes The Sun' with light wands, with the sun on the horizon behind him. It was about minus twenty degrees. Later on we thought the song title was too specific a reference to the Beatles and might land us in a spot of bother if we used it for the now emerging work, whatever form it took. Robyn suggested we might do a version called *There Goes The Ice*. In the end we made both versions and *There Goes The Ice* has since gone on to live in other musical ways.

With thanks to Robyn Hitchcock and Nathan Gallagher

Robyn Hitchcock on board the
Grigory Mikheev off the west coast
of Greenland 2008

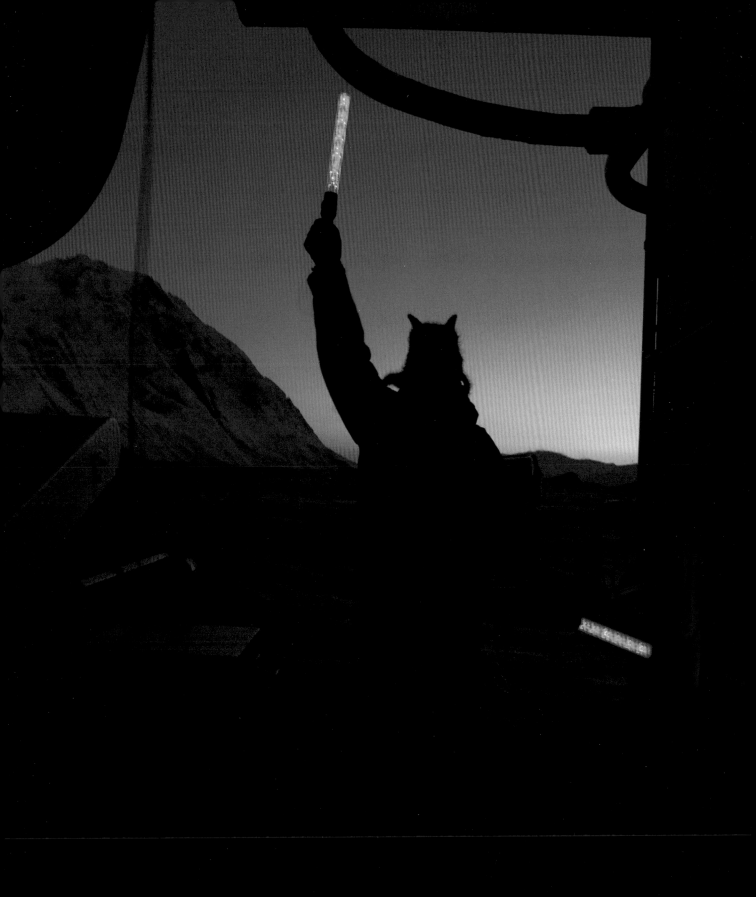

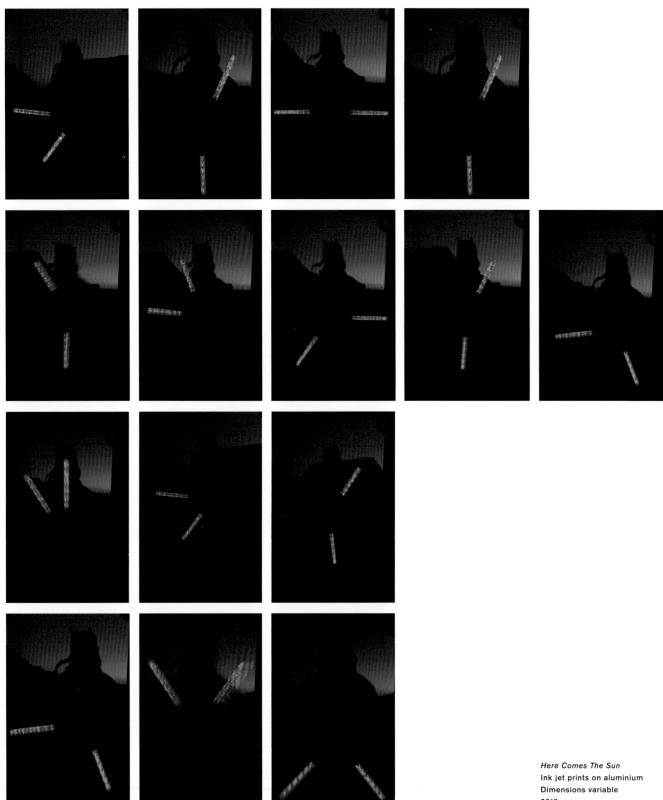

Here Comes The Sun
Ink jet prints on aluminium
Dimensions variable
2010

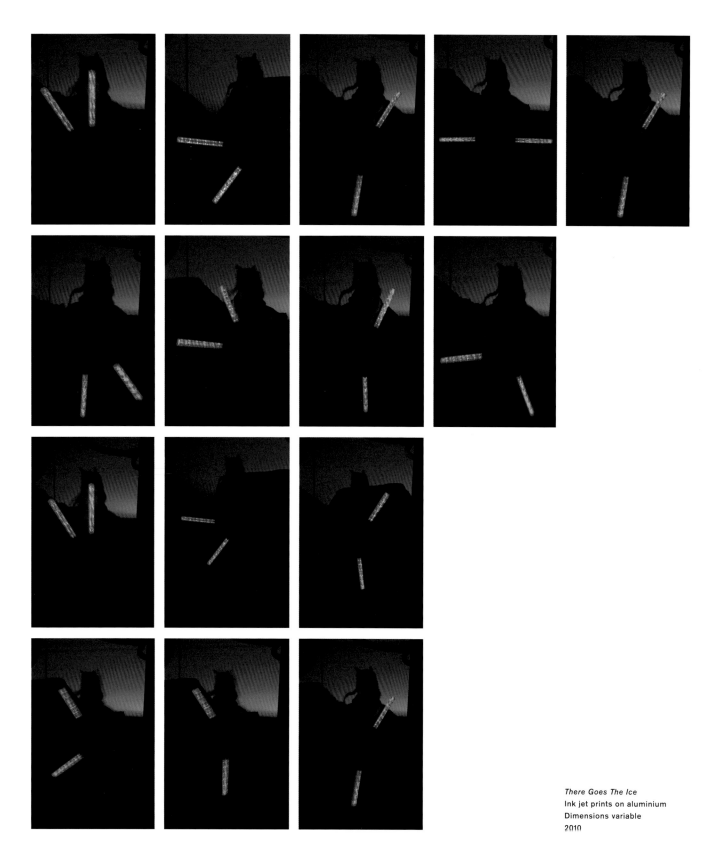

There Goes The Ice
Ink jet prints on aluminium
Dimensions variable
2010

Publication Partnership

This publication has been made possible through a unique collaboration between Camberwell, Chelsea and Wimbledon Colleges (CCW), University of the Arts London, Columbia College Chicago, and the University of Applied Arts Vienna in partnership with Cape Farewell.

The three university sector institutions share a reputation for delivering, promoting, and advocating the value and role of creativity, experimentation and critical cultural practices. They all demonstrate a commitment to placing the important issues of environment, sustainability and social engagement at the centre of their educational ethos.

This collaboration is a milestone for Cape Farewell and the institutions involved in hosting the exhibition. Unfold proposes a number of creative and innovative responses to climate change in a public context aimed at stimulating discourse and a wider engagement with the climate debate. It also provokes within the educational context a discussion around what are the legitimate agendas for creative arts education and arts practitioners, in relation to some of the most pressing and urgent issues of our times.

Camberwell, Chelsea and Wimbledon Colleges (CCW), University of the Arts London

At CCW we have established a series of overarching themes that are a catalyst for cross-disciplinary exchange and collaboration and a means of responding to broader social and cultural agendas that transcend subject specific concerns. In this respect, through a series of focused projects and events, together with external partners, and in conjunction with The Graduate School, we have identified three areas – *Climate Change*, *Identities* and *Technologies* – as issues to be explored in our teaching and research communities.

It is arguable that informed, critical and socially engaged practice draws its momentum from a reflection on, and an awareness of, current pertinent social, cultural and political aspects of life. Contemporary artists are primarily occupied with addressing and commenting on how they see and reflect the often complex, contradictory, stimulating and problematic world that they live in. A key aspect of the debate regarding the social responsibility of art and artists is essentially one of emphasis and concerns a clarification of the context for the artist and for how artistic practice is located and intended to function.

This brings into question the art school's relationship with external communities and of sustainable partnerships such as Cape Farewell. There needs to be a considered and strategic approach to position the art school as a generator of progressive and inclusive opportunities and as a centre for innovative cultural production that creates social and intellectual capital as well as economic opportunities.

This of course raises further questions about how the art school is both populated and supported. How we develop pedagogic models that embrace the need to contribute to and influence society in order to amplify both individual and collective voices on important and increasingly pressing social, political and environmental issues affecting our lives. How we achieve this whilst maintaining our independence, promoting experimentation and originality is arguably one of our greatest challenges for the future.

Professor Chris Wainwright
Head of Colleges, CCW,
University of the Arts London

Columbia College Chicago

At this moment in time, perhaps more than any other problem humanity faces, global climate change demands the kind of disciplinary approach we at Columbia College Chicago espouse. It is a problem we must face collectively, by embracing solutions from wherever they may emerge. Just as we must set aside the differences between the developed and developing worlds, divisions between the arts and sciences must be broken down in favour of collaborative problem solving. Together, we may discover that these divisions were largely false to begin with.

If creators can help translate the data-driven language of science and imbue it with the emotional impact of art without unnaturally compartmentalising the two, then perhaps humanity can inch closer to an understanding of our interconnectedness and our common obligation to engage in sustainable stewardship of our planet. Reaching this understanding is essential, given the need to reduce a problem so overwhelming to a human, personal scale.

The artists' work and the profoundly important ideas that form the foundation of Unfold resound strongly within Columbia College Chicago. Unfold brings the most important of connections – the link between concern for the earth and the creators of cultural ideas, artefacts and moments. The interplay of art and science is a key to the Cape Farewell project. It provides insight into the future of contemporary art practice, which is integrated with – rather than separate from – the sciences and other disciplines, signifying an important shift in the education of both artists and scientists.

The presence of Unfold at Columbia represents an opportunity to show rather than tell our students how the artist communicates – giving voice to the impact of the still-alterable course of climate change – allowing us to buttress what we teach in our classrooms with a real world example of how art and artists can be catalysts for positive social change. Civic engagement is not an option or an add-on, but a vital part of a creative professional's value. It is the means through which an artist will meet their obligation to shape contemporary discourse, not only among other artists, but also in matters social, cultural, political, economic, scientific and spiritual. The artist as public intellectual – as citizen – is a central tenet of a Columbia education.
That is why we are committed partners in Unfold and are proud to be the first North American venue to host this exhibition.

Furthermore, it is an opportunity to reach out to Chicago, the city we call home, and engage with its citizens on an issue of global importance.

Steve Kapelke
Provost / Senior Vice President,
Columbia College Chicago

David Buckland in Conversation with Chris Wainwright

This is an amended version first published by The European League of Institutes of The Arts (ELIA) in the Goteborg 10th Biennial Conference Papers, 2009.

In September 2008 Cape Farewell mounted its seventh expedition to the Arctic, taking a team of forty artists and scientists to Disko Bay on the west coast of Greenland to see the Jakobshavn Glacier, which is losing 20 million tons of ice every day. On the trip were artists Lori Anderson, Sophie Calle, musicians Jarvis Cocker, Ryuichi Sakamoto, Feist, Martha Wainwright and KT Tunstall, architect Sunand Prasad, poet Lemn Sissay, and Chicago-based filmmaker Peter Gilbert.

DB Cape Farewell came about from artistic enquiry. I'd come across mathematicians who were model building in the late 1990s. They'd constructed what is now a very famous climate model, the HadCM3, which had the structure and integrity for looking into the future climate of the planet. They had a really big problem – they knew that climate change was a reality, but the language they were using was the language of graphs and scientific data. The public wasn't engaging, so Cape Farewell was set up to construct a different language of talking about climate change. The idea was to gather the best creative brains we could find, put them with scientists, go up to the Arctic, into this extraordinary frontline situation with climate change and give them an open invitation to work with this as an idea. Sixty or seventy artists have been through the programme, and they've all come up with amazing ways of thinking about climate change.

The artists are challenging the way we live, our values and lifestyles. There have been seven expeditions so far; five with major artists and scientists and two with 16-year-old youths. We made a strategic decision last year to work with university students rather than youths, because they are used to working with artists, and it's not a separation. They can feed off each other.

CW I'm interested in the strategic decision that Cape Farewell took to work with young, emerging artists rather than youths. It suggests to me that within that choice there's also a challenge; that part of the motivation for working with students is not just to offer them the opportunity to engage with Cape Farewell, but to say to them, 'we think this is important that you engage with climate change, what do you think?' From where I'm sitting, I see it as a challenge for students as much as an opportunity. I don't know if that's the intention or not.

DB It's the same challenge for the artists. We work with the best artists we can find and ask them to address climate change. With the exception of one or two, they're not environmental artists. There's been a big debate on whether that has been a legitimate task since the inception of Cape Farewell. You're asking, is that a legitimate task to set the student to say, 'you can be the best painter, film-maker, fashion designer, but I want you to address climate change'.

CW As somebody who is responsible for running an art school, I'd say it's a legitimate task, because it challenges the notion of the curriculum, and of self-expression and in particular the art school as the place where people can develop their individual and collective creative ideas. There are some contentious arguments about the values of creative education that have actually moved away from some of the core responsibilities of artists to have to address social, cultural and economic issues as well as those issues about individual creativity.

If you go back to the basic premise that all artists do is tell you how they see the world, then I've got no problem with that. My only questions are, 'How big is that world? Is that the world you live in from day to day going from your flat to your studio, to the supermarket and home again, and your experiences about that? Or, is how you see the world influenced by issues such as climate change?' So, it's about the breadth, the reference and not so much about challenging the premise of what an artist should be. It's actually more to do with saying, if you are somebody who has a creative ability to see the world in a very particular way and tell people about it, and tell them about it confidently and in a way that's engaging through exhibitions, music, performance, then that world that you are seeing ought to have some relevance to other people.

DB There's also a greater notion of being right at the edge of knowing something, that edge where you're just trying to make sense of something that you can only just about touch, and it's probably an emotion. That is also a totally valid enquiry for me. The artist's job is to grab those things that are way out on the edge and somehow be able to articulate them.

But the thing about climate change is that the whole structure of society in which we live has evolved into something that is not sustainable. Over 6 billion people cannot carry on living like this. But the solutions are right on the edge of something out there and we need artists to try and articulate that curiosity.

CW Remember when you said to me, just before the trip, 'it's okay to come along and fail'. By saying it, you created the pressure not to fail. You upped the anti.

DB I know.

CW There were times on that voyage when people were completely at a loss as to how to deal with what they were experiencing, not because of a lack of confidence in their ability as artists or musicians, but because of the sheer enormity of the question. You can ask the question about climate change sitting here in the city, because there's lots of other things that you're asking questions about at the same time, the same day. When you're in the Arctic, the only question is climate change. The more you thought about it, the more you became completely incapable of understanding why we've got to the position that we're in. And I saw that as a sense of failure. Not personal failure, just failure to be able to assimilate the enormity of the problem.

DB This planet has certain major natural forces that are in balance. They are forces beyond imagination: the whole of the northern ice cap in the North Pole or the whole mass of ice on Greenland. They're so big that you can witness them, but if someone tells you they're not going to exist in five years' time, you can't even imagine the consequences. It is extraordinary that human activity can change one of those forces. Six billion of us doing the same thing is causing it.

CW And you feel that pressure when you're there with a small group of people right at the cutting edge of where that's happening. You're carrying the burden of six billion people's activities on your back.

DB Ian McEwan said when he was up there he realised one day that, except for probably a hundred people, everybody was south of him. It touches on artists dealing with being right on the edge of something and trying to drag it back. Every artist who's been there has told a personal story; that's how they've dealt with it. They've managed to make a human scale out of this enormous question and that is the most exciting thing that's come out of the whole process of the Cape Farewell project. Most of the work that the artists have done has not been in the Arctic, it's what they've done since they've come back.

CW One of the most interesting institutional and educationally challenging things to deal with is how you marry up the concerns of art and science in such a way that is both analysing a situation, and putting something out in a way that people will engage with.

DB When we first started, neither the scientific community nor the artistic community knew the outcomes. They trusted that through a process of doing, we would actually achieve what we couldn't think. The scientists at first thought the artists would illustrate their problem and then they soon realised that that's not what artists do. They somehow took hold of this amazing piece of scientific thinking and then transposed it into something completely different and came up with another way of visioning what the scientists were doing, but connecting it to human activity, the human story.

CW Ryuichi Sakamoto is an emblematic example of how an art and science collaboration can work in a way that is completely unexpected.

DB The geologists were towing a blaster behind the boat that would put sound down through two or three kilometres of sea to the rock at the seabed. The idea was that as the actual landmass of Greenland is underwater, as the ice melts in the middle of Greenland, the land rises and cause fusions in the seabed. So the geologists were trying to see if there were any major changes in the rock structure. As they were doing this they came up with these incredibly beautiful drawings of data that showed the seabed. Ryuichi asked them about the information and what form it was in. They said, 'it's digital information. We just take it into the computer and we digitalise it'. He said, 'I can turn it into music. I'll make a symphony that's half a million years old'. And that's what he's done – he's created a piece of music that is influenced by that whole process of taking the data and transforming it into a different way of thinking about time itself. Fabulous.

CW What that does is take the scientist's data and puts it into a public domain in a way that science could never achieve through its own mechanism of scientific journals, scientific conferences, or government reports. Ryuichi would reach a few thousand people a night!

DB Easily, and the story reaches thousands more, it's just brilliant. That's happened endlessly.

CW What amazed me was not just the potential for collaboration, but that in very short spaces of time people got it. People collaborated more quickly than they might have done if you'd had this slow evolving relationship over a number of years.

DB It's an interesting experiment to run in the art schools, because

you have painters, sculptors, etc, and you get them all addressing this one collective issue for a year. You're throwing people together and setting up a paradigm of a potential collaboration.

CW For me that reinforced a core belief that if you create a strong thematic, it forms a glue between different disciplines. I was completely knocked out by how musicians, artists, poets, geologists and a beatboxer came together in a way that was only possible because of the collective focus on climate change. For me, it strengthened the belief that within the creative educational context, we can set up big agendas for creative people to address, whether they're designers, filmmakers or ceramicists. You can bring these people together meaningfully, get everyone focusing on a much more important issue than what they do as an individual, and exciting things will come from that.

DB What you've just said there is quite a challenge to a lot of people. It's a bit like me saying, 'you can fail'.

CW I need to be conscious that whatever I do, the students will benefit from it. The opportunity came up for us to get involved with Cape Farewell's evening 'Late at Tate' in February. We invited students from Chelsea College to respond to the idea of a ton of carbon. Industrial design and fine art students worked on it for a week and produced an interpretation of a piece of work that Sunand Prasad and I did on the voyage – four helium weather balloons in a cube that represented one cubic ton of carbon dioxide, a tenth of what each of us produces each year. What a great experience for the students – they got Sunand, who was President of the Royal Institute of

British Architects, and me as tutors, they got materials, and the benefit of high-profile public exposure on the Parade Ground at Chelsea. Now they want to do something more with it and redevelop the project. So we seeded that with a group of people, but one of the really important things is putting a bit of pressure on them to do something, to produce something for an event. 'You've got a week to do it. It doesn't matter if you fail.'

DB No pressure!

CW It creates an anxiety in them that indicates they've got something really important to do. It's fantastic seeing people rise to that challenge. We can create real opportunities that aren't just about making work about climate change, they're about the students making things happen. We can say to them 'this is a project about now, and the time to deal with it is now. So don't put it off. Don't over-theorise the process'. And, to use one of your terms, David, 'it's about making'. It's bringing about awareness through actually doing something. That's not to say there isn't a sound theoretical or intellectual basis for it, but it's about direct action to a fairly direct problem.

DB But you're always aware of not making that a wasteful process. You make it as efficient as possible. So there's fine tuning to it; it's not just blind making. That's the artistic process.

CW How do you see Cape Farewell functioning now in relation to your vision for it when it was set up in 2002? How has the agenda shifted?

DB I think when we started there was a concern about how to translate the language of climate and climate science in particular and how

as artists we gained an understanding of the issues. Over time this has to some extent shifted to a more complex position of developing an engagement and a gradual understanding and commitment to creating a cultural shift as opposed to simply trying to create a process of measurement.

CW What do you think the impact of Cape Farewell has been on artists who have experienced Cape Farewell, and maybe more importantly, what has been the contribution to the climate debate?

DB One of the really exciting things to see is the way artists collaborate, both with each other and with scientists, in a real situation often at the front line of where climate change is happening. It's been a real challenge for all the artists to balance their practice in relation to addressing important issues around climate change. Cape Farewell creates opportunities for artists to fine tune their antennae and focus on climate without being didactic or working within a branded context. Cape Farewell does not prescribe cultural practice or possess a manifesto. The characteristics of how artists work individually and collectively is more of a viral process that contributes in a variety of ways to bringing about a cultural shift often in unexpected ways.

CW Where next for Cape Farewell, what's in the pipeline for the future?

DB One of the key aspects of the cultural practice that characterises our approach is the commitment to a process of action-based research that places practice at the centre. In that respect we are challenging the culture of evaluating the work of artists and projects we do through the prevailing

audit-based culture of measurement and impact assessment. We will continue to profile the work of artists, scientists and educators through our exhibitions, concerts, publications, events, talks and media exposure. All of this is in the public domain and to a large extent is measured by the process of public engagement. There are also future voyages planned and a new film from the last arctic voyage.

CW How do you balance your own artistic practice with being the leader of what has become a high profile and successful organisation?

DB To some extent many artists work within a complex set of organisational relationships and have to manage complex practices that involve collaboration, negotiation and fundraising for example. Being an artist and Director of Cape Farewell has some shared and common ways of working that's about an amplification of what it means to be an artist. There is also a question about how you define the role of an artist and what are the legitimate parameters of an artist's activity beyond that of producing work. There is however a time pressure that's about how to carve out time for focus and reflection on the art making aspects of my work, but I am sure this is true for many artists.

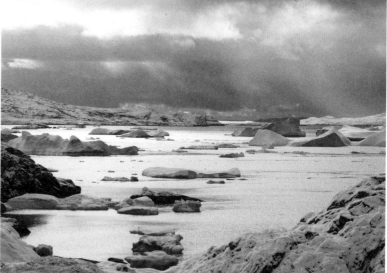

Biographies

Ackroyd & Harvey

Sculpture, photography, architecture and ecology are some of the disciplines that intersect in Ackroyd & Harvey's work. Structure, nature, control and randomness crossover to reveal an intrinsic bias towards process and event. Known for harnessing processes of growth and decay, and creating complex living photographs utilising the pigment chlorophyll, they show extensively in diverse contexts and often create interventions in public sites of architectural interest. In 2007 they grew grass from seed on London's National Theatre. Currently they are growing 300 sapling trees germinated from acorns collected from Joseph Beuys's seminal artwork *7000 Oaks*. *Beuys' Acorns* was shown at Earth: Art of a Changing World, 2010, Royal Academy, London. Other noted exhibitions include Bios 4, Andalusian Centre for Contemporary Art, Spain; Mostra SESC des Artes, Sao Paolo, Brazil; Sculpture Quadrennial, Latvia; Dilston Grove, London, UK. Since 2004 they have made expeditions to the Arctic with Cape Farewell, studying the effects of climate change on the fragile ecosystem and have exhibited resultant works at the Liverpool Biennial, Natural History Museum, London, UK, and Miraikan Museum, Japan.

Amy Balkin

Amy Balkin is an artist best known for spatially large-scale works whose medium is the land and the geopolitical relationships that frame it. These include *This Is The Public Domain*, an effort to initiate a permanent international commons on land near Tehachapi, California, and *Public Smog*, a clean-air park in the atmosphere, constructed through a series of economic and political activities and gestures. Two recent projects use reading to address the intersection of bureaucracy, climate change, political participation, and public speech – a participatory reading of the Intergovernmental Panel on Climate Change's 800-page Fourth Assessment Report on *Mitigation of Climate Change*, involving over fifty volunteer readers, and a video of the 2007 *IPCC Summary for Policymakers*. Recent exhibitions include The Cooper Union, New York, and a public billboard project in Douala, Cameroon.

David Buckland

David Buckland is an artist whose lens-based works have been exhibited worldwide. In 1999 Buckland presented a one-person show of digitally mastered portraits of performers at London's National Portrait Gallery. In 2000 Buckland created the Cape Farewell project, which he now directs. A major international Cape Farewell touring exhibition includes his video work *The End of Ice* and two series of black glass collodion based photographic pieces and a series of twelve photographic glacial text projections. Buckland's work was also shown in the UN touring Exhibition for World Environment Day. In 2007 he projected on to the Gehry stage, Millennium Park, Chicago an hour-long video work *Arctic* made in collaboration with the sound artist Max Eastley. He has produced two films for television, *Art from the Arctic* for the BBC, 2006, and *Burning Ice*, 2010. Recently he co-curated the exhibition Earth – Art of a Changing World, at Royal Academy, London.

Adriane Colburn

Adriane Colburn is an artist based in San Francisco, CA. She has exhibited her work throughout the US and internationally, at venues such as The Luggage Store Gallery and The Yerba Buena Center for the Arts in San Francisco, Artsterium in the Republic of Georgia and in the exhibition Earth: Art of a Changing World, 2010, Royal Academy, London. Her current work consists of large-scale installations that look at the ways maps are used to illuminate and investigate fragile and inaccessible ecosystems. She has recently participated in expeditions to remote parts of the planet, travelling on an Arctic seafloor mapping expedition with the Center for Coastal and Ocean Mapping, 2008 and to the Andes and Amazon with Cape Farewell, 2009. She has been an artist in residence at Headlands Center for the Arts, Macdowell Colony, Kala Institute and most recently, Blue Mountain Center, New York. Adriane teaches as a visiting lecturer at California College of Art and San Francisco Art Institute.

Sam Collins

Sam Collins is an artist, designer and collaborator based in London. Born in Hobart, Tasmania, he studied Sculpture at Curtin University of Technology, Perth, Western Australia. He has exhibited in numerous group and solo exhibitions, and in recent years has concentrated on the design and production of exhibitions, large-scale art projects, and theatre productions. He has worked with numerous artists, directors and choreographers including Siobhan Davies, Marina Abramovic and Matthew Barney and has been associated with Artangel and the Manchester International Festival for a number of years. As a Designer he has worked on a diverse range of projects from a hybrid Opera/Art Exhibition with curators Hans Ulrich Obrist and Philippe Parreno (Il Tempo del Postino – group show) to a contemporary Arabic production of

Shakespeare, with Sulayman Al Bassam Theatre Company (Richard III – An Arab Tragedy). Recent design projects include *Drifting and Tilting – the Songs of Scott Walker*, at Barbican London, and *Longplayer Live* at Roundhouse, London.

Nick Edwards

Nick Edwards was born in Bristol and grew up in Camberley, Surrey, before moving to London to work in the film industry. His first exhibition, at Submarine Gallery, King's Cross, 1987, consisted entirely of re-cycled material. Over the past five years he has been a participating artist with Cape Farewell. For the Cape Farewell project Nick produced a triptych of moving images, inspired by sketches of the Arctic and his fascination with the mythology of exploration. The work is shown on three framed flat screen televisions and consists of a long invisibly looped animation of sea and landscapes. He recently completed a commission for the newly refurbished Manchester Royal Infirmary, consisting of a portrait of a Manchester Poplar, an animated 18 minute film.

Leslie Feist

Leslie Feist is a Canadian singer who performs under the name Feist. She was born in Amherst, Nova Scotia, and grew up in Calgary. She soared to international acclaim with her most recent album, *The Reminder*, which sold more than a million copies worldwide and earned four Grammy nominations. She won five Juno Awards in 2008, including Single of the Year, Artist of the Year, and Album of the Year.

Francesca Galeazzi

Francesca Galeazzi is an artist and architectural engineer. She works as a sustainability specialist in the architectural design studio of Arup Associates in Shanghai, China and London, UK. In her artistic practice she constructs sculptural installations probing the dynamics between physical and mental spaces, meant to engage the viewer on multiple sensory levels. Her recent work focuses on the issues of climate change and urbanisation, in which she uses a variety of media, employing projection, sculpture, drawing, painting and performance. In 2007 she was awarded a Master in Fine Art at Central Saint Martins College of Art and Design, University of the Arts London, UK. Her recent exhibitions include: At Play II, Bracknell Gallery, South Hill Park, London, 2010; New York Art Book Fair, 2009; Foundation, solo show, Bloomsbury Design, London, 2007; In>visible Traces, Old Boys Club Dalston, London, 2007. Since 2002 Francesca regularly lectures on environmental sustainability and climate change in the field of architecture at London Metropolitan University and is an invited speaker at major universities and conferences worldwide.

Nathan Gallagher

Nathan Gallagher was on the Disko Bay, Greenland expedition, 2008, working with the Cape Farewell team and voyagers to document the various art and science projects and the overall ambience of the expedition. Since his return his Arctic photographs have been used in exhibitions and various print media to promote and represent the work of Cape Farewell. Nathan is a photographer and musician based in London and has gained a reputation in particular for his snowboard and ski photography, although his work and commissions have taken him all over the world.

Marije de Haas

Marije de Haas is working to set up Floda31: a creative facility in North Sweden where individuals from various disciplines can collaborate to find solutions to the global problem of climate change. Marije was one of the founding members of the successful all media company Bullet Creative founded in 1999. Bullet's strength is creative solutions – it uses any media necessary to communicate the right message. Bullet was awarded a Bafta for interactive learning in 2001, a World e-science award in 2005 and was an honoree for a Webby Award in 2009. Clients include Cape Farewell, Nike, Open University and Siobhan Davies Dance.

Robyn Hitchcock

Robyn Hitchcock is a surrealistic English songwriter who began making records in 1977. Primarily a singer and guitarist, he plays piano, bass and harmonica; he also draws, paints and occasionally takes photographs. He has worked with Peter Buck, Jonathan Demme, Gillian Welch and other great Americans.

Ian McEwan

Ian McEwan's works have earned him worldwide critical acclaim. Among them are the Somerset Maugham Award (1976) for his first collection of short stories *First Love, Last Rites*; Whitbread Novel Award (1987) and Prix Fémina Etranger (1993) for *The Child in Time*; and Germany's Shakespeare Prize (1999). He has been shortlisted for the Man Booker Prize for Fiction numerous times, winning the award for *Amsterdam* in 1998. In addition to his prose fiction, Ian McEwan has written plays for television and film screenplays. Film adaptations of his own

novels include *First Love, Last Rites* (1997), *The Cement Garden* (1993); *The Comfort of Strangers* (1991) and *Atonement* (2007). His most recent novel is *Solar* (2010). His voyage with Cape Farewell to the Arctic inspired him to write this climate change focused narrative.

Brenndan McGuire

Brenndan McGuire is a music producer, sound designer and live sound engineer. He is founder of Gleaner Audio, a company that salvages used electronics and resurrects them into new products and designs. Born in Toronto, Canada, Brenndan now spends time in the Mojave Desert renovating his Airstream trailer into a recording studio.

Daro Montag

Daro Montag is an artist, and Reader in Art & Environment at University College Falmouth, Cornwall, UK. He is particularly interested in exploring the inherent creativity of living organisms and natural processes. Best known for colourful images made in collaboration with micro-organisms, he has also worked with toads, newts, insects and earthworms as well as weather events of wind and rain. His most recent project examines the cultural and ecological significance of soil and its importance as a carbon sink to mitigate climate change. Daro's work has been exhibited in the UK, Europe, the USA and the United Arab Emirates, and published in a number of books. In 2002 he was awarded a prestigious art-science prize in Tokyo. He currently leads the RANE research group (rane-research.org) and the MA in Art & Environment, Falmouth, UK.

Michèle Noach

Michèle Noach was born in Sydney, Australia and lived in Holland and the US before her family settled in London in the last hours of the 1960s. She had pet mice, loved The Velvet Underground and wrote for the music press for several years. Her interest in code-breaking led to her becoming a cryptic crossword compiler and to qualify in British Sign Language. She studied print-making and has been with The Curwen Gallery, London, since 1989, and exhibiting in the UK and internationally. Her 2005 show 'Nø-äch's Årc-tic' reflected her expedition experiences with Cape Farewell, as does this new series *Through The Ice, Darkly*. Michèle is Artist-In-Residence at Eden Project, studying the Arctic poppy and in 2008 exhibited her lenticular installation *The Glasshouse Men* in the greenhouses of The Lost Gardens of Heligan. She is currently working on 3-dmiensional images of cloud/glacier cycles in Northern Norway.

Lucy + Jorge Orta

Lucy Orta was born in Sutton Coldfield, UK / Jorge Orta was born in Rosario, Argentina. Contemporary artists Lucy + Jorge Orta have been collaborating since 1991. Their studios, The Dairy and Les Moulins, two historical buildings for the production of their artworks, commissions and limited editions, are situated in central Paris. The artist duo assembles their artwork and installations together with a team of curators, artists, architects, designers, skilled technicians and craftsmen employing a range of techniques including sculpture, object making, couture, painting, printing and light projections. Parallel, and feeding into their studio practice, they stage ephemeral interventions, performances and workshops. Lucy + Jorge Orta have exhibited their work in major contemporary art museums around the world including: Hangar Biccoca, Milano; Fondazione Bevilaqua La Masa, Venezia; Barbican Art Gallery, London; Museum Boijmans Van Beuningen, Rotterdam; ICA, London; Modern Art Museum, Paris; Museum of Contemporary Art, Sydney; as well as the Venice, Havana and Johannesburg Biennials.

Sunand Prasad

The award winning architectural practice Sunand Prasad co-founded is well known for its commitment to sustainable design that puts people at its centre and engages with other art forms. Former President of the Royal Institute of British Architects (RIBA), he was a founding member of the Commissioners of the UK Government's Commission for Architecture and the Built Environment (CABE). He has written about climate change, architecture and cultural diversity, the value of design, urbanism, the domestic architecture of North India, and the work of Le Corbusier. Sunand has taught and lectured in many schools of architecture and lives with his family in a house designed and built with friends. He is a member of the London Mayor's design advisory panel and chairs CABE's Eco-Towns Design Reviews.

Tracey Rowledge

Tracey Rowledge studied Fine Art at Goldsmiths, University of London, UK and Fine Bookbinding and Conservation at Guildford College of Further and Higher Education, UK. She makes work using the materials of bookbinding to explore the relationship between process and spontaneity. Her work has been shown internationally and is held in various private and

public collections including The British Library, The National Library of Scotland and The National Art Library (Victoria and Albert Museum). Tracey has received a number of awards, the most recent was support from Crafts Council, London to go on the 2008 Cape Farewell Expedition to Disko Bay, West Greenland. Tracey is a founding member of the independent artists group 60|40, formed in 2008 with Clare Twomey and David Clarke. Project by project, 60|40 aims to expand the environment and opportunities for the applied arts. Tracey is also a founding member of Tomorrow's Past, an international bookbinding collective.

Lemn Sissay

Lemn Sissay MBE is author of five poetry collections and the editor of *The Fire People: A Collection of Contemporary Black British Poets*. His most recent collection of poems, *Listener*, is published by the award-winning publisher Canongate. Lemn is artist in residence at Southbank Centre, London and Patron of The Letterbox Club, a Book Trust initiative to get books to children in the care of the social services. His poems have become landmarks, the most recent *The Gilt of Cain* was unveiled by Bishop Desmond Tutu in the City of London. Lemn also presents and writes radio documentaries, writes plays for the stage and BBC radio. His work has been the inspiration for a concerto at the BBC Proms and was included on the award-winning album *Leftism* by Leftfield. He initiated *Global Poetry System,* an online user generated resource that maps the poetry in our environment in both its physical and emotional landscape. Lemn Sissay lives in London. www.lemnsissay.com

Shiro Takatani

Shiro Takatani graduated from Environmental Design – Art Department, Kyoto City University of Arts. He joined Dumb Type as one of the founders in 1984, and has been involved especially in its visual and technical aspects. In 2007, Takatani created an audio visual installation *LIFE – fluid, invisible, inaudible…* in collaboration with Ryuichi Sakamoto, commissioned by YCAM (Yamaguchi Center for Arts and Media). The DVD version of *LIFE – fluid, invisible, inaudible…* was released in May 2008. Also, Takatani travelled to the Arctic (Greenland and Iceland) by sailboat joining the arctic expedition project Cape Farewell in 2007. Recently he created a new performance *Die Helle Kammer* during a three-week residency in Halle, Germany. The world premiere was in June 2008, as part of the Theater der Welt Festival in Halle. He was presented with his work in the exhibition Earth – Art of a Changing World at GSK Contemporary / Royal Academy, London, UK.

KT Tunstall

Since wowing the nation on *Later… With Jools Holland*, KT Tunstall has become a festival favourite from Glastonbury to T in the Park. KT secured a Mercury Music Prize nomination for *Eye to the Telescope*, outsold every other female artist in the UK in 2005, won a Brit Award for Best British Female Solo Artist, the Ivor Novello Best Song award for writing 'Suddenly I See' and landed a Grammy nomination for Best Female Pop Vocal Performance.

Clare Twomey

Clare Twomey is a British artist who works with clay in large-scale installations, sculptures and site-specific works. Twomey's work has been exhibited in the UK at Tate Gallery, Liverpool, Victoria and Albert Museum, MIMA, Crafts Council, Eden Project, Royal Academy and the Museum of Modern Art, Kyoto, Japan. She has developed work that expands the fields of knowledge of larger-scale installation. The themes of Twomey's works are influenced by observations of human interaction and behaviour, environment and interpretation. Twomey continues to develop work that pursues her interest in space, architectural interventions and site-specific responses. She is actively involved in critical research in the area of the applied arts, including writing, curating and making.

Chris Wainwright

Chris Wainwright is an artist, curator and Head of Camberwell, Chelsea and Wimbledon Colleges, the University of the Arts London, UK. He is also President of The European League of Institutes of the Arts (ELIA), an organisation representing over 350 European Higher Arts Institutions. He is currently a member of Tate Britain Council and a board member of Cape Farewell. He has been in numerous one person and group exhibitions in the UK and worldwide. Recent exhibitions include The Moons of Higashiyama, Kodai-ji temple, Kyoto, Japan; The Night of a Thousand Lights, Nara, Japan; Trauma, Culturalcentrum, Brugge, Belgium; Between Land and Sea, Box 38, Ostende, Belgium. His work is represented in many major public and private collections including: Victoria and Albert Museum, London; Arts Council England; Bibliothèque Nationale, Paris; the Polaroid Corporation, Boston, USA, and Unilever, London.

Expedition Participants
2007–2009

2007 Art & Science Expedition

Amy Balkin
Kathy Barber
Simon Boxall
Marcus Brigstocke
David Buckland
Nick Cobbing
Carol Cotterill
Beth Derbyshire
Liam Frost
Aminatu Goumar
Dan Harvey
Ben Jervey
Brian Jungen
Vicky Long
Dallas Murphy
Caroline Ross-Pirie
Vikram Seth
Shiro Takatani
Emily Venables
Matt Wainwright

2008 Disko Bay Expedition

Mojisola Adebayo
Laurie Anderson
Kathy Barber
Hannah Bird
Simon Boxall
Marcus Brigstocke
David Buckland
Luke Bullen
Sophie Calle
Vanessa Carton
Jarvis Cocker
Sam Collins
Quentin Cooper
Carol Cotterill
Jonathan Dove
Teresa Elwes
Leslie Feist
Francesca Galeazzi
Nathan Gallagher
Peter Gilbert
Graham Hill
Robyn Hitchcock
Jude Kelly
Nicole Krauss
Ruth Little
Vicky Long
Lori Majewski
Michèle Noach
David Noble
Suzan-Lori Parks
Zak Piper
Sunand Prasad
Tracey Rowledge
Ryuichi Sakamoto
Shlomo
Adam Singer
Lemn Sissay
Dave Smith
Joe Smith
Adam Sora
Norika Sora
Julian Stair
KT Tunstall
Emily Venables
Chris Wainwright
Martha Wainwright
Matt Wainwright

2007 Art & Science Expedition

2009 Andes Expedition

Hannah Bird
Kathryn Clark
Adriane Colburn
Josh Fisher
Ana Cecilia Gonzales Vigil
Marije de Haas
Charlie Kronick
Yadvinder Malhi
Marlene Mamani Solorzano
Yann Martel
Brenndan McGuire
Daro Montag
Lucy + Jorge Orta
Angela Rozas Davila
Rhian Salmon
Anthony Santoro
Matt Wainwright

2009 Andes Expedition

2008 Disko Bay Expedition

Exhibition

Curators
David Buckland, Chris Wainwright

Assistant curator and exhibition organiser
Nina Horstmann

Publication

Editors
David Buckland, Chris Wainwright

Copy editor
Anne Lydiat

Editoral team
Nina Horstmann, Kate Sedwell

Editorial board
Gerald Bast, Steve Kapelke

Proof reader
Diana Yeh

Design
Paulus M. Dreibholz

Print
Holzhausen Druck GmbH

Photos
Nathan Gallagher, Arctic: pages 4, 6 (bottom), 9, 17,
18, 23, 111 (bottom), 117 (bottom), 120 and dust jacket;
Ana Cecilia Gonzales Vigil, Andes: pages 6 (top), 10,
111 (top), 117 (top); Nick Cobbing: page 116

Printed on acid-free and chlorine-free bleached paper,
FSC certified

© 2010 Springer-Verlag/Wien
SpringerWienNewYork is a part of
Springer Science + Business Media
springer.at

SPIN: 80014203
ISSN: 1866-248X
ISBN: 978-3-7091-0220-6
Library of Congress Control Number:
2010926581

SpringerWienNewYork

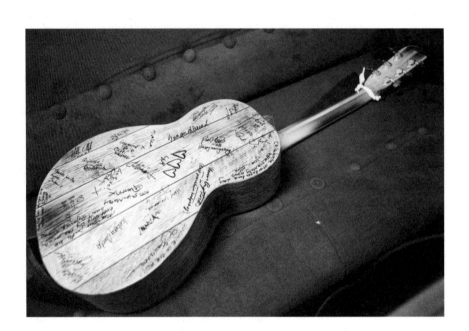